CONTENTS

W9-BJC-990

AFRICAN ART AND INDIAN ART OF THE AMERICAS

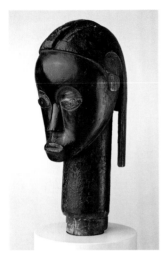

1 Communion with the dead is an important focus of art and ritual for the Fang people of southern Cameroon and Gabon. This large, serene Reliquary Head was made to sit with its neck inserted into the lid of a bark box that held the remains of an honored ancestor. Kept in a dark corner of a man's sleeping room, the head and box protected the remains and embodied the deceased. The sleek and refined features—including a high forehead, jutting chin, and elongated nose—highlight classic qualities of Fang figural abstraction.

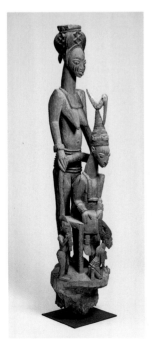

2 The Veranda Post of an Enthroned King and His Senior Wife, by the Yoruba sculptor Olowe of Ise (died 1938), was commissioned for the royal palace at Ikere, in present-day Nigeria. Masterfully representing Yoruba concepts of divine rulership, the sculpture portrays the king seated and leaning forward under his large, beaded crown. At a Yoruba ruler's coronation, his senior wife—here the regal figure standing over the king—places the crown, invested with spiritually charged medicines, on his head. Armed with political and spiritual acumen, she also helps to protect his interests during his reign.

3 Among the Bamana of central
Mali, farming is an ancient and noble
profession that is entwined with reli-
gious beliefs and ritual practices. The
invention of agriculture is credited
to a mythical hero named Ci Wara,
literally "farming animal," who was
half human and half beast. These
Ci Wara Headdresses combine the
graceful head, neck, and horns of the
antelope with the short legs, compact

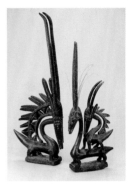

body, and tough, pointed nose (used to dig into hard, dry
ground) of the pangolin, or scaly anteater. Such head-
dresses, in male and female pairs, are worn in ceremonial
performances. The female carries a spry young male on
her back, suggesting the fertile union of men and women
and of earth, water, seeds, and sun.

4 In the highlands of Ethiopia, Orthodox Christianity
stretches in an unbroken line of practice from the 4th
century to the present day. Although painted icons are
known from the late 14th century, demand for such
objects increased greatly in the mid-15th century, when
the worship of Mary was formalized in the Ethiopian
Orthodox liturgy. Icons were venerated in weekly services
and on special feast days. The central image of this large,
finely rendered Triptych Icon presents Mary with the

young Jesus on her
lap, enthroned on
an Ethiopian-style
bed, flanked by the
archangels Gabriel
and Michael.

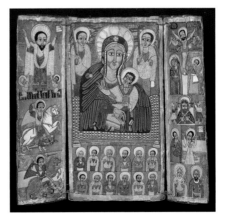

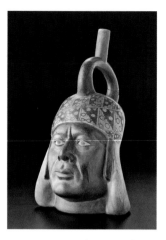

5 Before Columbus arrived in the "New World," great civilizations thrived in Central and South America, with the most powerful centered in the modern nations of Mexico, Guatemala, and Peru. Between the 1st century B.C. and the 5th century A.D., the Moche of Peru produced a naturalistic ceramic art that included portraits of great individuality and expressive power. This Portrait Vessel depicts a forceful ruler. Such vessels were placed in graves along with others that display aspects of the Moche world. In this respect, these wares correspond to the tomb paintings found in other early civilizations.

6 Teotihuacan, whose ruins are located near Mexico City, was one of the largest and most complex cities in the world during the first millennium A.D. Although this Mask, made from the inner layer of *Spondylus* shell, shares features common to others from the city—a broad forehead, prominent nose, receding chin, and widely spaced cheekbones—it is subtly unique, indicating that it represents a stylized portrait. Tied to wooden armatures adorned with feathers, jewelry, and garments, such masks were displayed in residential compounds and

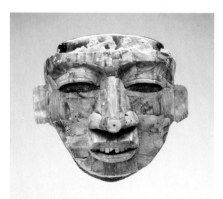

temples where they were the focus of rituals commemorating ancestors who acted as intermediaries between the community and the deified forces of nature.

7 According to ancient Maya belief, after several failed attempts, the gods succeeded in populating the earth when they created humanity out of maize, the staff of life. The Vessel of the Dancing Lords, from the Late Classic period (A.D. 600–800), depicts three Maya rulers attired as the maize god. Each one is accompanied by a dwarf; among the Maya, dwarfs were considered special beings with powerful spiritual connections to the earth and underworld. This vessel may refer to a rite of passage in which dwarfs assist the soul of the deceased into the domain of the dead.

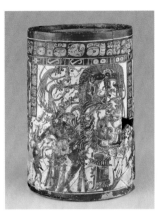

8 This sculpture, commemorating the beginning of the reign of Emperor Motecuhzoma II, was originally located within the ritual center of Tenochtitlan, the capital of the extensive empire established by the Aztecs (Mexica) between 1428 and 1519. Known as the Stone of the Five Suns, this monument draws connections between Aztec history and the cosmic scheme. The quadrangular block is carved with the hieroglyphic signs of five successive eras—mythic cycles of creation and destruction that were called "suns" in the language of the Aztecs. The sculpture legitimizes Motecuhzoma's rule as a part of the larger cycles of birth, death, and renewal and shows him as heir to the world in the present era of creation.

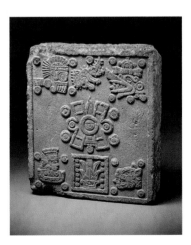

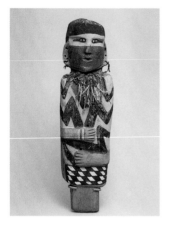

9 For thousands of years, the American Southwest supported an Indian population that produced some of the finest architecture, ceramics, textiles, and other works of art created in the ancient Americas. This Sculpture from a Ritual Cache is attributed to the Salado branch of the Mogollon culture, which flourished in what is today eastern Arizona between the 14th and 15th centuries. It was part of a shrine and was discovered wrapped and stored in a cave. Natural formations were important features of ancient geography as places for communication with the life-giving spirits of the earth and sky. A variety of materials—wood, feathers, ocher, and other pigments—invest this figure with religious meanings and helped to establish bonds between the community and the sacred forces of nature.

10 The Pomo were especially accomplished designers and weavers of baskets for all purposes, and the cone-shaped Burden Basket is a well-known form in their artistic repertoire. This late-19th-century example is in excellent condition considering both its age and the fact that it was made for utilitarian purposes. The basket is beautifully woven with a diagonal twine; alternating triangular motifs in dark brown and light tan escalate

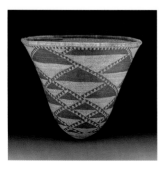

in size from the bottom to the rim. Serrated lines of smaller triangles separate the dominant shapes and reinforce the overall sense of spiraling, diagonal movement. Ancient basketry preceded ceramics and influenced many shapes and designs of later pottery.

AMERICAN ART

11 Colonial silver often reflects prevailing European styles and techniques. This Two-Handled Covered Cup, made by Cornelius Kierstede, demonstrates the fine craftsmanship that was present in America by the late 17th century. The cast

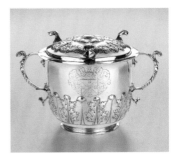

handles, wrought cup, and engraved Baroque coat of arms continue European traditions. Such cups were used at baptisms, weddings, and other celebrations to toast the occasion.

12 Largely self-taught, Bostonian John Singleton Copley often relied, like English artists, on European prints for compositional models. In fact, the pose, gown, drapery, and billowing cloud in the background of Mrs. Daniel Hubbard (Mary Greene) were inspired by a mezzotint portrait of an English noblewoman. Achieving a balance between honesty and sophistication, Copley created convincing images of 18th-century Americans that continue to move us through their incisive character-ization and precise execution.

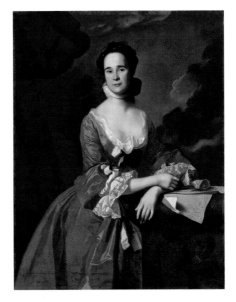

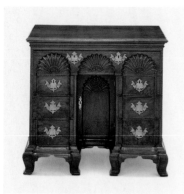

13 By the mid-1700s, prosperity created a demand for the services of fine cabinetmakers in Newport, Rhode Island, and elsewhere along the Atlantic coast. Attributed to John Townsend, this Bureau Table is typical of the outstanding furniture made by the celebrated Townsend and Goddard families of Newport. With its sophisticated alternation of convex and concave sections surmounted by finely carved shell forms, the bureau table exemplifies the original concepts evolving in American furniture by the mid-18th century.

14 In this terracotta portrait bust of General Andrew Jackson, William Rush demonstrated the naturalism and blend of subtlety and strength that helped to make him an accomplished sculptor. By the time Rush executed the portrait, Jackson was a national military hero. Rush avoided grandiosity in his depiction of the 52-year-

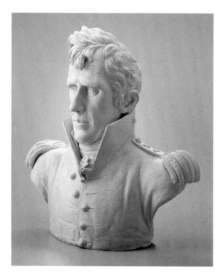

old general; rather, Jackson's alert gaze, energy, and dignity are compelling and befit a great soldier on his way to becoming a statesman.

15 Harriet Hosmer's work frequently addresses the theme of strong women punished for their power and ambition. This portrait bust depicts Zenobia, Queen of Palmyra, who ruled the Syrian city following the death of her husband, Odenathus, in A.D. 267. Zenobia conquered Egypt and much of Asia Minor before being defeated by the Roman emperor Aurelian in

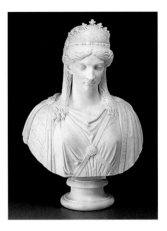

272. Hosmer portrayed Zenobia's dignity at the moment of her capture, calling her "calm, grand, and strong within herself."

16 Early in his career, Winslow Homer sought to depict human activity out of doors and in sunlight. Between 1865 and 1869, he executed paintings and drawings on the theme of croquet, a game recently introduced to America from England. Croquet Scene is notable for its bold patterning, strong contours, and brilliant light effects, which Homer used to create a sense of immediacy. The painting, with its gaily dressed figures, epitomizes the spirit of a casual and breezy summer afternoon.

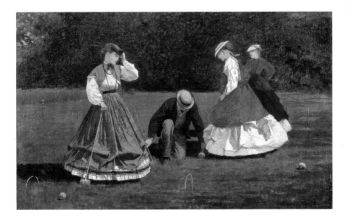

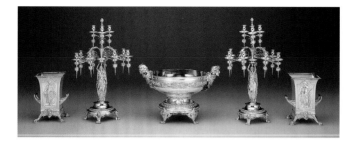

17 By the late 19th century, Tiffany and Company, located in New York City, had become one of the largest and most accomplished silver manufactories in the world. The firm offered both domestic wares and spectacular presentation pieces, such as this Geneva Tribunal Testimonial, in a variety of historical and exotic styles. This Neo-Grec example includes two candelabra, a matching punch bowl, and two wine coolers. The suite was commissioned by the United States government in 1873.

18 Following the lead of English designers intent upon reforming an industry that produced poorly designed and constructed furniture, Gustave and Christian Herter's firm, operating in New York City during the late 19th century, executed remarkable furniture for wealthy clients. In this Cabinet, the painted roundels and floral inlays reveal the influence of Japanese art prevalent at the time.

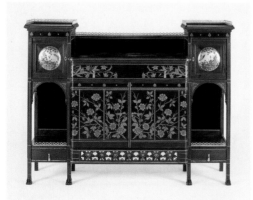

19 Childe Hassam's The Little Pond, Appledore depicts a quiet, rippling body of water surrounded by breeze-blown grasses and color-ful flowers. The painting represents

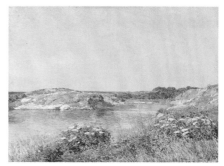

Hassam's deliberate efforts, after his experiences in Paris with Impressionism, to brighten his palette and capture the effects of light on color and shape. With its inviting openness and shimmering light, this landscape dem-onstrates the mastery that made him a leader among American Impressionist painters.

20 Responding to Japanese prints, Mary Cassatt cre-ated unorthodox compositions such as The Child's Bath, which displays then-unconventional devices like an elevated vantage point, cropping of forms, and bold out-lines. In her portrayals of women and children, Cassatt avoided sentimental-ity. In this painting, the crisp, clear forms and lively patterns are as appealing as the private, domestic mo-ment we are permitted to witness.

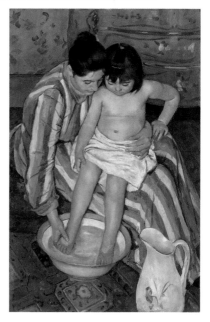

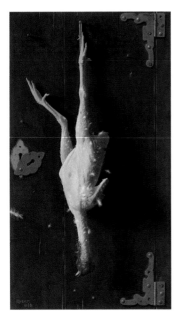

21 William Michael Harnett made objects look so lifelike that they seem real (this approach is known by the French term *trompe l'oeil*, or "deceive the eye"). In works such as For Sunday's Dinner, he revealed a characteristic irreverence and humor. The life-size image of the plucked chicken, meticulously rendered down to the drop of blood on its beak, has been placed uncomfortably close to the viewer. The door, with its assorted blemishes and loose lock revealing an unpainted section of wood, bears a signature that appears to have been carved into the wood in the lower left corner.

22 The depth of emotion and characterization in Thomas Eakins's portraits has seldom been surpassed. A native of Philadelphia, he studied at the Pennsylvania Academy of the Fine Arts before devoting three years to European academic training. His portraits, such as

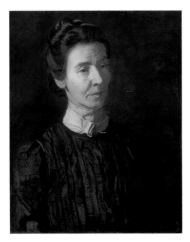

Mary Adeline Williams, are solidly structured and uncompromisingly honest. Williams was a dear friend of Eakins and his wife and, for a time, a member of their household. She is portrayed here with the sympathy of one who knew her intimately.

23 Many 19th-century American artists embodied the lofty goals and epic history of their proud young nation in allegorical figures based on Classical prototypes. Sculptor Daniel Chester French devoted his career to creating large-scale figures and groups for buildings and monuments like the Lincoln Memorial in Washington, D.C. The artist sculpted this life-size study of Truth for the facade of the Minnesota State Capitol in Saint Paul. The classicism of

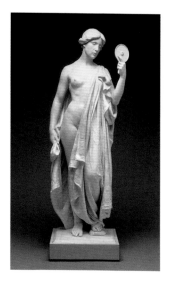

this elegant, draped nude is tempered by French's naturalistic approach and mastery of form.

24 The architect Frank Lloyd Wright considered furniture "architectural sculpture." Wright and George Mann Neidecken designed this Desk for Wright's Avery Coonley House in Riverside, Illinois (see also no. 40). The lines and masses of this imposing piece—including its rectilinear shapes, columnar supports, and lamp shades—are sympathetic with Wright's Prairie School architecture and the exterior design of the Coonley House.

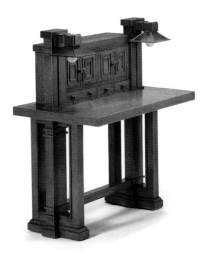

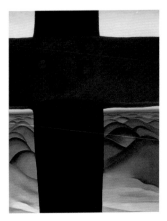

25 The pioneers of American abstraction responded to modern European movements in individual ways. Georgia O'Keeffe approached her subjects—whether buildings or flowers, landscapes or bones—by intuitively magnifying their shapes and simplifying their details to underscore their essential beauty. Black Cross, New Mexico was painted during a summer visit to that state, where O'Keeffe eventually settled. The large, dark cross seems to stand watch over the rolling hills at sunset, proclaiming man's presence in this stark landscape.

26 Grant Wood adopted the precise realism of 15th-century northern European painters, but the artist's native Iowa provided him with his subject matter. American Gothic depicts a farmer and his spinster daughter posing before their house, whose gabled window and tracery, in the American Gothic style, inspired the painting's title. In fact, the models were the painter's sister and his dentist. Wood was accused of creating a satire on the intolerance and rigidity that the insular

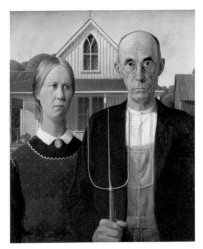

nature of rural life can produce—a charge he denied. *American Gothic* is an image that epitomizes the Puritan ethic and virtues that he believed dignified the midwestern character.

27 Although Horace Pippin was a native of Pennsylvania and had been to the South only once, Cabin in the Cotton depicts a 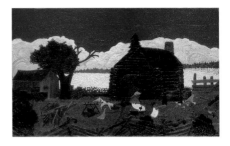 rural farmhouse with directness and a surprising sense of familiarity. Southern life was an immensely popular theme in 1930s America, with *Gone with the Wind* and *Porgy and Bess* capturing the national imagination. This painting shows that an African American artist like Pippin might also have a sentimental view of the difficult life of cotton growers.

28 With their carefully constructed compositions and elusive meanings, Edward Hopper's paintings have a timeless, universal quality that transcends the particular locale or subject depicted. The austere beauty of Hopper's Nighthawks is due to the artist's understanding of the expressive possibilities of light playing upon simplified shapes. *Nighthawks* is an unforgettable image of an all-night diner in which a soda jerk and three customers, all of them lost in their own thoughts, have gathered. Like a reassuring beacon, the light shining through the curved windows seems to protest the dark silence of the streets.

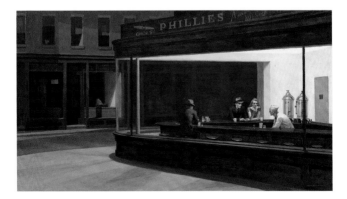

ANCIENT AND BYZANTINE ART

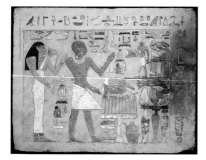

29 The function of Egyptian tomb art was to preserve scenes of daily life for the afterlife. This Wall Fragment from a tomb chapel portrays the official Amenemhet and his wife, Hemet. It served to immortalize the family for eternity through the preservation of their images, names, and food offerings. The hieroglyphic text calls upon the god Osiris to grant them sustenance in the afterlife. The well-preserved pigment is a good reminder that most Egyptian monuments were originally brightly colored.

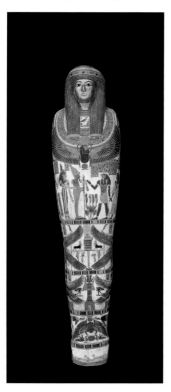

30 Mummification is the ancient Egyptian funerary practice of drying out a corpse for preservation. This vividly painted Mummy Case was the innermost of a series of shells that housed the body of a deceased person. The hieroglyphic inscriptions and painted scenes identify this mummy as Paankhenamun, a doorkeeper in the temple of the god Amun. The central scene shows the hawk-headed god Horus presenting Paankhenamun to Osiris, ruler of the afterlife.

31 By the 8th century B.C.,
the Etruscans were a wealthy
civilization living in the region
of central Italy known today
as Tuscany, and they were well
situated to trade with other
cultures of the Mediterranean.
They were avid collectors of the
fine black- and red-figure pot-
tery of Athens, many examples
of which have been found in
Etruscan tombs. Clever Etruscan
potters began making their own

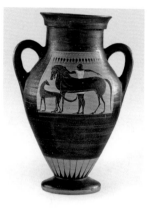

versions of Athenian wares, such as this Amphora, or
storage jar, with two scenes related to hunting. On one
side a man readies his horse and dog, while on the other
side his potential prey, a stag and a hare, flee.

32 This bronze figure of the Etruscan sun god, Usil, was
once one of three identical feet of a cosmetic storage
box called a cista. Taking advantage of the fact that they
lived in an area rich in the natural resources needed
for making bronze, the Etruscans became known for
their superb craftsmanship in metalwork and their abil-
ity to render fine details in small-scale works, such as
the facial features and ar-
ranged hair on this piece.
Skipping across the
crests of the waves, the
figure on this Cista Foot
embodies the playful
nature of Etruscan art.

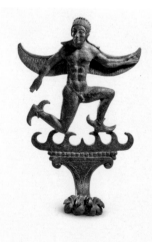

33 This refined Athenian Stamnos, or mixing jar, was used to mix wine and water. The red-figure vessel (so called because the figures remain the natural color of the clay) probably portrays maenads, female participants in rites celebrating Dionysos, the god of wine. These stately women convey a serenity that is a hallmark of this artist (who is referred to as the Chicago Painter because of this vase) and that has been used to identify other works by him, principally similar stamnoi.

34 This Funerary Fragment comes from a large tombstone in the shape of a lekythos, a small terracotta jar often left at a grave. Inscriptions identify the three figures. To the left, wearing a long himation, or mantle, stands Leon, who is further identified as coming from the town of Halai. He clasps hands with and gazes at Demagora, the woman seated before him. Presumably

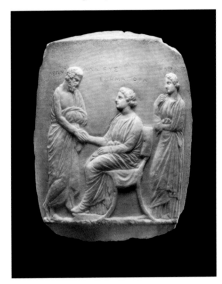

she is his wife, and the girl standing behind her is their daughter, Helike, who watches the couple bid each other eternal farewell.

35 The part-human, part-goat Silenos is a creature associated with the wine god Dionysos. Frequently drunk and randy, these carefree rustic spirits represented the hedonistic desires of mankind that were released by the god's magical elixir. This bronze silenos is one of a pair that once decorated the headboard of an elaborate couch used by diners at the lavish banquets of the

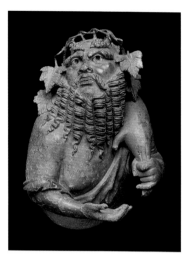

Roman elite. Because wine was served at such festive events, creatures from Dionysos's entourage were popular subjects for furniture attachments.

36 The name of the woman depicted in this Portrait Bust is not known, but her elaborate coiffure, which emulates a fashion trend set by Empress Faustina the Elder, wife of Antoninus Pius (r. A.D. 138–61), and her daughter Faustina the Younger, suggests that she lived during their lifetimes. Her opulent headband and richly textured clothing indicate that she held a prominent position in Roman society, likely as a priestess of the imperial cult, a state-sponsored religion that honored emperors and empresses who were deified after their deaths.

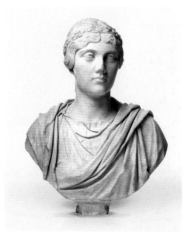

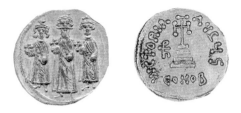

37 This gold Solidus, a type of coin from the reign of
the emperor Heraclius (r. A.D. 610–41), emphasizes the
importance of dynastic succession in the Byzantine
Empire, and also the emperor's god-given right to rule.
On the front side, the emperor is flanked by his two
sons, Heraclius Constantine and Heraclonas, also called
Constantine. The reverse shows four steps surmounted
by a cross, calling to mind the monumental cross that
was erected in the 4th century on the site of Christ's
crucifixion in Jerusalem.

38 This Mosaic Fragment was once part of a larger
composition that paved the floor of a villa in the
Eastern Mediterranean region. Composed of thou-
sands of small tesserae, or stone cubes, it shows
a giraffe and a human handler standing against a
decorative backdrop of scallop-shaped semicircles.
No doubt originally set amid a profusion of other

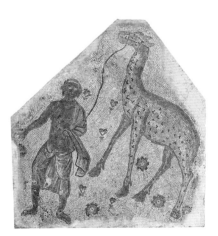

wild and exotic ani-
mals, giraffes such
as this one captivated
the imagination
of those who saw
them in parades and
public games.

ARCHITECTURE AND DESIGN

39 Chicago has been the major center for American architecture since the late 19th century. One of the city's most important early architects was Louis Sullivan, who, with his partner, Dankmar

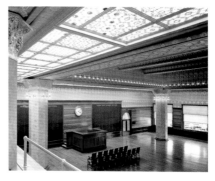

Adler, designed the Chicago Stock Exchange Building, constructed in 1893–94. When the Stock Exchange Building was demolished in 1972, sections of Sullivan's elaborate stenciled decorations, molded plaster capitals, and art glass were preserved from the Trading Room, the magnificent centerpiece of the 13-story structure. Using these fragments, the Art Institute was able to reconstruct the Trading Room in 1976–77.

40 Undoubtedly America's most famous architect, Frank Lloyd Wright established his reputation between 1900 and 1910, designing residences in what has become known as the Prairie style. In designing interiors, Wright explored the use of glass both as a decorative elment and as a transparent screen to unite outside and inside. In this Triptych Window from the Avery Coonley Playhouse in Riverside, Illinois (see also no. 24), built in 1912, Wright used images of balloons, the American flag, and checkerboard patterns to create a colorful, playful arrangement.

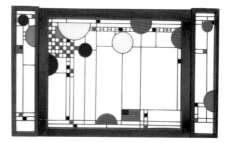

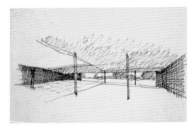

41 Ludwig Mies van der Rohe is widely recognized as one of the most influential figures in the development of modern architecture. Operating on a principle of "less is more," he utilized materials such as industrial steel and plate glass in his strikingly minimal designs, which are notably free of decorative forms. This Court House Study depicts a vast, open interior in which two slender columns provide the only visible means of support. The wide-angle perspective emphasizes the building's strong horizontal character. A nearly seamless wall of glass fills living areas with light and dissolves the boundary between interior and exterior.

42 Elizabeth Diller and Ricardo Scofidio explore the transformation of the human body in works such as Automarionette. Recalling the work of Marcel Duchamp, this drawing depicts an architectural appara-

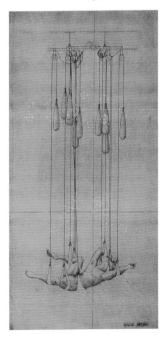

tus that holds a body suspended in the air. The horizontal position of the figure is regulated by a counterweight system that adjusts to gravity. A modified version of the structure was produced for the performance piece *The Rotary Notary and His Hot Plate (A Delay in Glass)*, which took place at the Philadelphia Museum of Art's Duchamp Centennial in 1987.

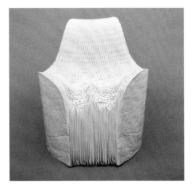

43 Tokujin Yoshioka's Honey-Pop Armchair defies the notion of furniture as merely functional. Both sculptural and ethereal, this chair, made entirely of paper, without an underlying frame, is like an oversize, intricate work of origami, supported entirely by a complex of hexagons made out of 120 layers of paper glued together. The name Honey-Pop refers not only to its resemblance to a giant honeycomb but also to the legacy of Pop Art, which championed commonplace yet unorthodox materials. At its premiere in 2002, Yoshioka cut the chair from a thick roll of the layered paper, opened it up like a book, and then sat on it to demonstrate its tensile strength.

44 Studio Gang's 82-story Aqua Tower is among Chicago's most important tall buildings of the last ten years. The tower's urban context helped determine its undulating surface, resulting in unique concrete balconies designed to contribute a graphic wave pattern to the building's facade, while controlling solar exposure and allowing for expansive views of the city and Lake Michigan. Inspired by the flow of wind, water, and topography, the Aqua Tower's facade was designed and fabricated with a combination of digital and analog techniques to create mass-produced, yet custom-made, forms.

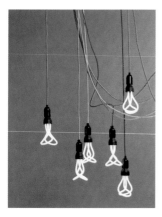

45 Challenging the sterile functionalism of compact fluorescent lightbulbs, London design company Hulger and British product designer Samuel Wilkinson reimagined these devices as aesthetic objects in their own right. Wilkinson drew on the raw qualities of the glass tubing used in low-energy bulbs to create a dynamic sculptural form. Like the best high-tech retoolings of traditional designs, the Plumen lightbulb pays homage to history with references to the arching shape of the filaments in early incandescent bulbs, while promoting the cause of energy conservation for the future.

46 Flight Patterns is a time-lapse animation that employs data visualization and Processing, an open-source computer programming environment, in order to display American air-traffic patterns and densities over a 24-hour period. Begun as part of a larger project at UCLA with designers Scott Hessels and Gabriel Dunne, Aaron Koblin's animations follow the routes of 140,000 airplanes crossing the United States beginning at 5:00 p.m. Eastern time. Koblin uses variations of color and pattern to illustrate a wide range of data and events, including aircraft type, alterations to routes, changes in flight traffic over certain geographical areas, varying weather patterns, and no-fly zones.

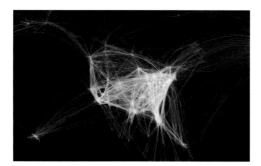

ASIAN ART

47 In their intricate surface designs and complex casting techniques, bronze vessels created by Chinese artisans of the late Shang dynasty (13th–11th century B.C.) display unparalleled virtuosity. The surface of this square-shouldered Wine Vessel is decorated with low- and high-relief patterns of ogre masks, dragons, birds, and cicadas. Although the meaning 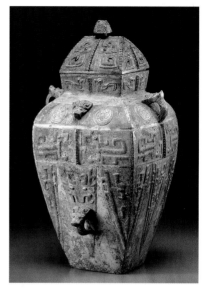 of this imagery eludes modern interpretation, Shang texts relate that kings and nobles used these vessels in ceremonies of ancestor worship. The Shang aristocracy paid homage to a supreme deity through the intercession of their ancestors and also buried ritual vessels as gifts to the departed.

48 Hard, fine-grained, and resistant to carving, jade must be laboriously worn away with a paste of wet abrasives. The central rectangle of this Sheath with Bird and Feline or Dragon (3rd–2nd century B.C.) has been drilled and ground in two superimposed layers to contain a thin blade. In their elegant fluency and rhythm, these decorative elements display an artful manipulation of descriptive form and abstract ornament that belie the tough, unyielding quality of the stone.

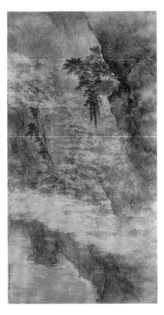

49 Trained in Shanghai and San Francisco and now living in the United States, Li Huayi is one of the most creative and accomplished Chinese painters working today. This Landscape is remarkable in its rigorous but expressive method of painting. After defining the composition with large areas of ink spilled onto the paper or worked with a broad brush, Li gradually rendered mass and solidity with denser layers and then allowed the paper to dry before adding details with a small, finely tapered brush.

50 Bishamon is the chief of the four guardian devas who protect the four cardinal directions in a Buddhist sanctuary. Together they defend the entire world against evil and promote the seeking of enlightenment. Glaring at those who pose a danger to the Buddhist law,

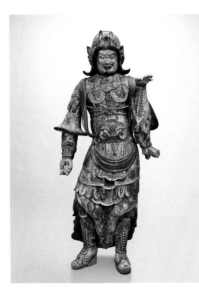

Bishamon is clothed in full armor, ready to take on the Buddha's enemies. The figure is carved from wood in an intricate style that conveys action while also rendering the smallest details of his costume. The dynamic representation of Bishamon's figure effectively expresses the guardian's strength and determination.

51 East Asian scrolls are unrolled from right to left, revealing successive scenes section by section. A rare Japanese scroll from the first half of the 14th century, Legends of the Yūzū Nembutsu illustrates the life of a 12th-century Buddhist priest, Ryōnin. In this scene, Ryōnin is shown receiving the tenets of the Yūzū Nembutsu faith from the Amida Buddha. The expressive, illustrative style of such narrative handscrolls reached its peak in medieval Japan.

52 Woodblock prints are regarded as the most characteristic expression of the Japanese artistic genius. Great quantities of this popular art form, called *ukiyo-e* (pictures of the floating world), were made during the Edo period (1615–1868), and most were sold inexpensively to a pleasure-seeking public captivated by Kabuki theater, sumo wrestling, and brothel districts. Prints such as Kaigetsudo Anchi's Beauty, woodblock printed in black with hand-coloring added, display a freedom and originality that were not possible in the rendering of tradition-bound religious images. The beautiful woman clutches her billowing kimono, which has been decorated with the words of a poem.

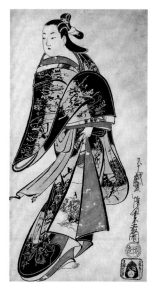

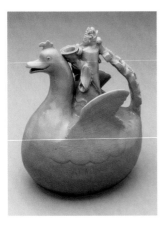

53 Korean potters were among the most skilled and imaginative craftsmen in East Asia. In this whimsical, 12th-century Ewer, a crowned immortal rides astride a plump, crested waterbird. The bird's wings are extended as if in flight, and its tail swoops up to form the handle. Liquids could be poured into the round vessel held by the rider and out through the bird's smiling beak. A luminous celadon glaze sheathes the entire vessel.

54 The monumental granite sculpture Karttikeya, God of War, Seated on a Peacock is probably from the Madanapalle region of Andhra Pradesh. Carved in the round and riding a peacock, the commander of the gods is shown with 6 heads (*shanmukha*) and 12 arms, 10 of which hold aloft weapons. The multiple arms and heads of Hindu deities usually denote their superhuman power.

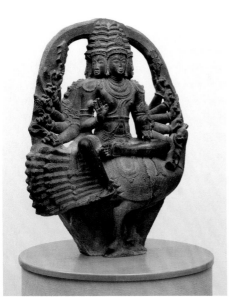

55 Although monkeys are as plentiful in India as pigeons are in Venice, depictions of them—especially portraits as monumental and finely detailed as this Portrait of a Monkey—are rare. Furthermore, this is no ordinary

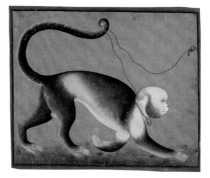

simian: this one has human features, complete with a bald head, a beard wrapping over his ears and down his face, pale eyes, and long slender hands. An inscription on the back of the painting identifies this particular creature as "Husaini," a pet owned by Nawab Daud Khan. The nawab was probably Daud Khan Panni, who served the Mughal emperors in the early 18th century. He was known to be fond of animals and kept a menagerie.

56 Vasudhara, the Buddhist goddess of wealth, presides at the center of this multitiered Mandala of Vasudhara, Goddess of Wealth, which serves to remind the devotee of the god's presence in the cosmos. She is especially popular with the Buddhist Newari people of the Kathmandu Valley in Nepal, who would probably use such an object for rituals dedicated to her in either the temple or the home.

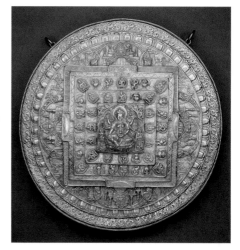

57 This inlaid brass Bowl (*tas* in Farsi) is a testament to the caliber of craftsmanship in Iran during the 14th century. The motif on the outside of the vessel depicts horsemen engaged in games of polo and hunting. This decorative program represents an iconographic tradition that inspired artists working in other media in 14th-century Iran, and similar imagery may be found in contemporary manuscript painting. On the inside of the bowl is a solar disk surrounded by a swarm of fish: an appropriate motif for a vessel meant to hold a liquid that would reflect light.

58 During the 16th and 17th centuries, at the height of the Ottoman empire, ceramic vessels and tiles of remarkable artistic and technical quality were produced at Iznik, a city in northwestern Anatolia. The enduring quality of Iznik at its best and most representative is the effect of bold patterning in brilliant polychrome set against a pure white ground. The design here consists of elaborate palmettes and sinuously writhing leaves with serrated edges. These two Tiles in the Art Institute's collection can be dated to about 1560, the height of Iznik tile production.

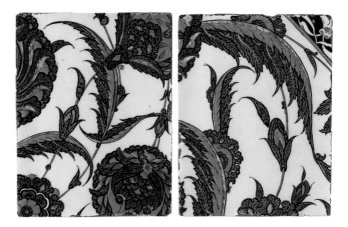

CONTEMPORARY ART

59 Willem de Kooning was a central figure in Abstract Expressionism, an art movement that construed the painterly actions of the artist as a sign of his or her emotions. In Excavation the sheer energy of the painted surface binds together

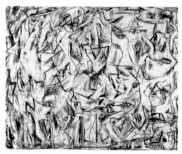

shattered figural and natural forms. Aptly titled, the work reflects de Kooning's technically masterful painting process: an intensive building up of the surface and scraping down of its paint layers, often for months, until the desired effect was achieved.

60 Robert Rauschenberg is best known for his "combines," a hybrid form of painting and sculpture that integrates humble materials and found images to bridge what he called "the gap between art and life." Before submitting this combine, Short Circuit, to an exhibition in 1955, he invited friends to produce small pieces that could be smuggled into the show via his cabinet-shaped construction. A painting by his former wife, artist Susan Weil, appears behind the right door, and a flag composition by Jasper Johns, later replaced by a facsimile, once sat behind the left door. The work also includes a Judy Garland autograph, an image of Abraham Lincoln, and a postcard of grazing cows.

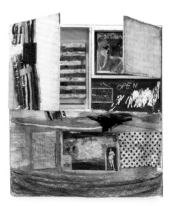

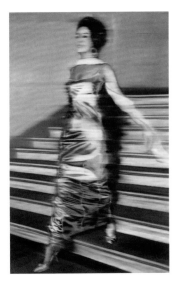

61 Cy Twombly's distinctive canvases merge drawing, painting, and symbolic writing in the pursuit of a direct, intuitive form of expression. Using improvisational gesture and allegorical narrative, Twombly often evokes classical mythology in his works. The First Part of the Return from Parnassus refers to Mount Parnassus, the fabled home of Apollo and the Muses, which became known as the center of poetry, music, and learning in ancient Greece. A related work, *The Second Part of the Return from Parnassus* (also from 1961), is in the Art Institute's collection as well.

62 Woman Descending the Staircase is one of Gerhard Richter's Photo paintings, figurative works in which the artist enlarged and transferred found photographs, such as personal snapshots or media images, onto canvas and then dragged a dry brush through the wet pigment, thus blurring the image and making the forms appear elusive. Here the slightly out-of-focus quality reinforces the motion of an unknown, glamorously dressed woman descending a set of stairs, creating a hauntingly sophisticated image that floats between reality and illusion.

63 Eva Hesse produced an extraordinarily original, influential body of work in her short career, pioneering the use of eccentric materials and idiosyncratic sculptural forms. Hang Up is an ironic sculpture about painting, privileging the medium's marginal features: the frame and its hanging device, represented by the cord that protrudes awkwardly into the

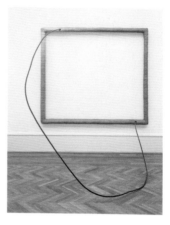

gallery. The title might be understood as a humorous instruction for the sculpture's display, but also acts on a more psychological level. Collapsing the space between the viewer and the artwork, *Hang Up* distorts our ability to discern a clear demarcation between painting and sculpture.

64 The most influential of Pop artists, Andy Warhol cast a cool, ironic light on the pervasiveness of commercial culture and contemporary celebrity worship. In this example from his *Mao* series, Warhol melded his signature style with the scale of totalitarian propaganda to address the cult of personality surrounding the Chinese ruler Mao Zedong (1893–1976). Warhol's looming portrait *Mao* impresses us with the duality of its realistic qualities and its plastic artificiality. Ultimately, the gestural handling of color in the portrait shows Warhol at his most painterly.

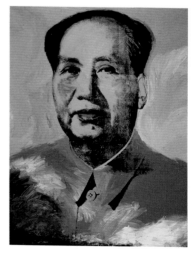

65 Roy Lichtenstein famously mined the visual clichés of graphic illustration and cartoons and embraced the look of mass-produced images in his fine-art paintings. Referencing a long tradition of rendering mirrors in art, Mirror #3 (Six Panels) is the largest of the artist's *Mirror* series of paintings (1969–72). The disjointed planes of the work suggest the influence of Cubism. Only stylized gleam and shadow are reflected in Lichtenstein's mirror; thus, the puzzling, fragmented, even conceptual abstraction becomes the real subject of the work.

66 Inspired by the names of urban housing projects, Kerry James Marshall explored the triumphs and failures of these much-maligned developments in a series titled *Garden Project*. Set in Chicago's now-demolished Stateway Gardens, Many Mansions depicts three men tending an elaborate garden. Negating misperceptions of the black male, the dark-skinned trio beautifies the harsh surroundings. The red ribbon in the background bears the message "In My Mother's House There

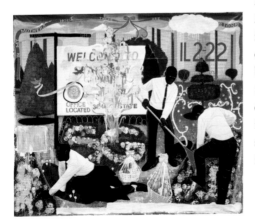

Are Many Mansions"; this feminist gloss on a famous biblical phrase (John 14:2) expresses an inclusive understanding of the idea of home.

67 Epic and elegant, *Near the Lagoon* is the largest and last work to be completed in Jasper Johns's *Catenary* series (1997–2003). The term *catenary* describes the curve assumed by a cord suspended freely from two fixed points. Johns formed his catenaries by tacking ordinary household string to the canvas or its supports. The string activates and engages the abstract, collaged field of multitonal gray behind it.

The catenaries are also Johns's playful attempt to show a work's front, side, and back from a single vantage point, as the cord strongly suggests a picture's hanging device.

68 Determined to make a sculpture of a felled tree, Charles Ray found the source for *Hinoki* while hiking in the woods of central California. Aided by several assistants, Ray transported the giant oak tree back to his studio and made a fiberglass reconstruction of it. The copy was then sent to Osaka, Japan, where master woodcarvers, working by eye from the model, painstakingly rendered a life-size replica out of Japanese hinoki cypress (*Chamaecyparis obtusa*). The use of this pristine, sturdy wood to create a sculpture of an already partially collapsed and rotted tree is pointed: Ray both re-created and extended the tree's life cycle.

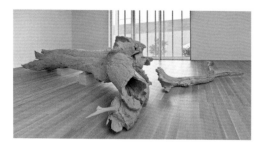

EUROPEAN DECORATIVE ARTS

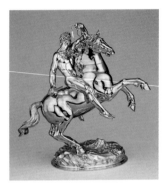

69 This extraordinary sculptural group, Cup in the Form of a Rearing Horse and Rider, is a rare example of the work of Hans Ludwig Kienle, a German silversmith who specialized in depicting animals. Conceived as a drinking cup, the vessel may be based on an earlier bronze sculptural group made in northern Italy during the mid- to late 16th century. Kienle's skill in working with precious metals is especially exceptional; to convey the differences between human and equine musculature, Kienle contrasted silver and gilt-silver surfaces, thus animating the already dynamic subject.

70 The cabinetmaker André-Charles Boulle was responsible for some of the finest examples of French furniture made during the reign of Louis XIV (1643–1715). This rectangular Casket, which would have stored precious jewels, is richly veneered with marquetry panels of scrolls, strapwork, and vines executed in engraved gilt copper on a ground of tortoiseshell. Framing the panels are strips of ebony and pewter. The casket also features gilt-bronze mounts in the form of male, female, and animal heads.

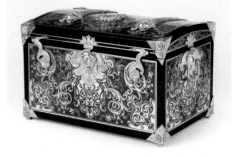

71 Around 1728 Augustus II, the Elector of Saxony and King of Poland, conceived of replicating the animal and bird kingdoms in porcelain. By 1733 more than 30 different models of birds and almost 40 animals had been made, many by the sculptor Johann Joachim Kändler. Kändler modeled this King Vulture from life, which enabled him to express the creature's

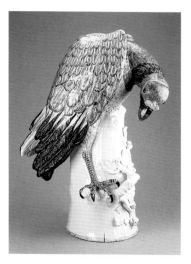

quintessential spirit. Such porcelain animals remain the most vivid expression of Augustus's wish to possess and rule over the natural world.

72 Mounted with gold plaques and painted with colored enamels and gilding, this Gaming Set opens to reveal four small, similarly decorated porcelain containers that hold gambling chips. With its liberal display of gold and diamonds, this work was certainly among the most extravagant and costly objects crafted at the Du Paquier Porcelain Manufactory in Vienna, Austria. It has been suggested that the box may have been a diplomatic gift from the Austrian Habsburgs to their Russian Romanov counterparts.

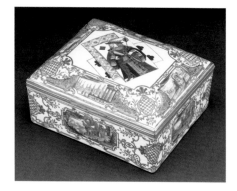

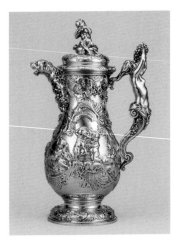

73 Some of the most accomplished examples of English Rococo silver are associated with the German émigré silversmith Charles Frederick Kandler. This Wine Jug is modeled with fully three-dimensional figures associated with Bacchus, the Roman god of wine. These include the seated infant Pan playing his pipes, the head of a panther with shoulders encircled by grape vines, and a maiden holding a cluster of grapes in her upstretched arms. These elements form, respectively, the finial of the jug's lid, the spout, and the handle.

74 The German furniture makers Abraham and David Roentgen opened shops in Berlin, Vienna, and Paris to handle commissions for aristocratic clients, among them King Louis XVI of France. Made about 1775, this

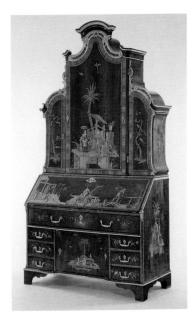

impressive Secretary Desk features the grand scale, complex contours, hidden compartments, fine ormolu hardware and mounts, and intricate pictorial wood inlays that are typical of an age that delighted in extravagant form and virtuoso performance.

75 The Londonderry Vase was one of the most ambitious undertakings of the imperial porcelain manufactory at Sèvres, France. With its commanding contours, monumental size, symmetrical decorations, and unabashed splendor, the vase is a superb example of the Empire style, inspired by Roman imperial art. Designed while Napoleon was emperor by his chief architect, Charles Percier, but produced after the Restoration, it was presented by Louis XVIII to the 2nd Marquess of Londonderry on the eve of the 1814 Congress of Vienna.

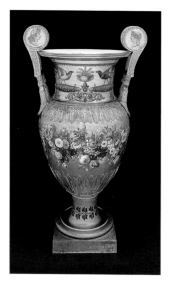

76 Edward William Godwin first designed his ebonized Sideboard, of which this is a variant model, for his own dining room in 1867, and he subsequently reconsidered the form in examples produced over the next two decades. With its balance of solids and voids, the work represents a turning away from Gothic Revival aesthetics in favor of the reductivist sensibility that would emerge at the turn of the 20th century.

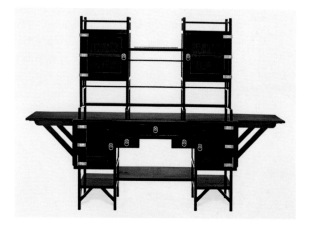

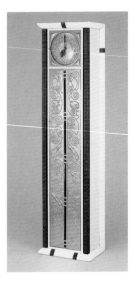

77 In 1903 the Wiener Werkstätte (Vienna Workshop) was established by a number of artists, designers, and craftsmen to produce objects that were both useful and beautiful. The austere casing of this Tall-Case Clock was designed by the architect Josef Hoffmann; its exuberant brass front doors were designed by Carl Otto Czeschka. The spiral patterns of the metal relief are in the late-19th-century Art Nouveau style, whereas the clean, simple lines of the clock itself are characteristic of the functional approach that came to dominate 20th-century design.

78 The 68 Thorne Miniature Rooms enable viewers to glimpse elements of European interiors from the late 13th century to the 1930s and American interiors from the 17th century to the 1930s. Painstakingly constructed on a scale of one inch to one foot, these fascinating models were conceived by Mrs. James Ward Thorne of Chicago and constructed between 1937 and 1940 by master craftsmen according to her specifications. The English Drawing Room of the Georgian Period, c. 1800, reproduced here in detail, was intended to illustrate the late-18th-century Neoclassical style of designer Thomas Sheraton, distinguished by elegant, light shapes and colors. The furniture replicas, made in England, include a harpsichord that is strung with wires attached to movable ivory keys.

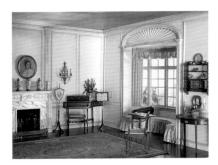

MEDIEVAL TO MODERN EUROPEAN PAINTING AND SCULPTURE

79 From early Christian times, relics, which were tangible evidence of the lives of Christ, the Virgin, and the saints, were much revered and were preserved in costly containers or reliquaries. Often exquisitely worked of precious metals

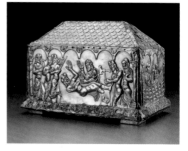

and jewels, reliquaries honored both the saint and the church that possessed the relics, since some of the spiritual authority of the holy personage was considered to be present through their remains. This Casket housed a relic of Saint Adrian, a Roman officer whose martyrdom is shown in gruesome detail in narrative panels made from hammered silver.

80 Among the Art Institute's treasures are six extraordinary panels from an early Renaissance altarpiece illustrating the life of Saint John the Baptist by the 15th-century Italian master Giovanni di Paolo. In Ecce Agnus Dei (Behold the Lamb of God), the tall, bony figures act out the story with animation and fervor. The landscape of checkered fields, tortured rocks, and scalloped riverbanks constitutes an appropriately visionary backdrop for the depiction of the life of this great mystic.

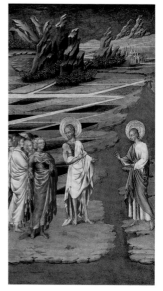

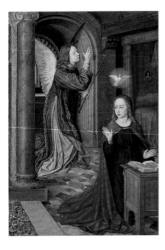

81 Although The Annunciation appears to be an independent painting, it is actually a fragment that once formed the right side of an altarpiece. Jean Hey worked in Moulins for Duke Pierre II of Bourbon and his wife, Anne of France, who played a large role in the government of France during the minority of Anne's brother Charles VIII. As their court painter, Hey, who was probably of Netherlandish origin, fused the intense naturalism and preciousness of Flemish and French painting and manuscript illumination with the emerging Renaissance interest in antiquity, as is evident in this painting's Italianate architecture.

82 The Assumption of the Virgin was the focal point of

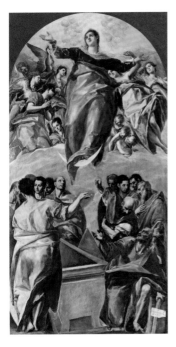

a monumental ensemble El Greco made for the high altar of a convent in Toledo, Spain. The large canvas seems barely able to contain the energy of the gesturing apostles and angels and the majestic figure of the Virgin ascending to heaven on a crescent moon. The composition is divided into two zones—earthly and heavenly—connected by a complex network of gestures and poses and a palette of silvery, almost supernatural colors. *The Assumption* is considered the artist's greatest painting outside Spain.

83 In his bronze relief The Annunciation, the Venetian Renaissance sculptor Alessandro Vittoria transmuted into metal the flickering light and colorful palette of the great Venetian painters of the period. Working in wax (from which the finished relief was then cast into bronze), Vittoria manipulated the piece's forms and edges to catch light. The result is a highly animated surface in which everything—figures, drapery, clouds, and sky—

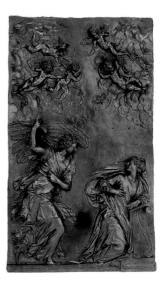

seems to vibrate with movement and excitement.

84 An outstanding example of the virtuoso objects produced by Nuremberg goldsmiths at the end of the 16th century, this Ewer and Basin was probably made more for display than for the ceremonial washing of hands that was its nominal function. The original owner of this silver-gilt set has not been identified, but it was likely to have been acquired to mark an important event, such as a marriage or the birth of a child. Medallions on both the ewer and the basin are filled with a variety of sea gods treated in a rich, pictorial manner. Their forms were created by hammering the metal from the reverse; the surface was then polished to produce a range of harmonious textures.

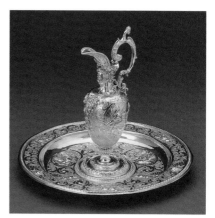

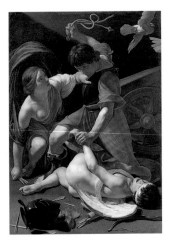

85 Bartolomeo Manfredi chose not to interpret the stories of the Bible and Classical mythology as idealized subjects enacted by heroic protagonists, but rather as events that happened, or could have happened, to ordinary people. In Cupid Chastised, Mars, the god of war, beats Cupid for having caused his affair with Venus, which exposed him to the derision of the other gods. Using dramatic light effects and depicting the action as close to the viewer as possible, Manfredi conveyed with great immediacy and power this tale of domestic discord, which also symbolizes the eternal conflict between love and war.

86 Francesco Mochi was a 17th-century sculptor whose work contributed to the birth of the Baroque style in Italy. His art is distinguished by dynamic forms, psychological nuances, and a razor-edged linearity. In Bust of a Youth, spectacularly carved curls of hair set off the dreamy gaze of a boy who may represent the young

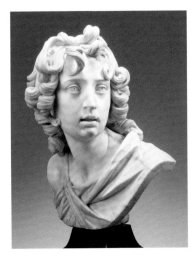

Saint John the Baptist. Saint John played an important role in Mochi's life: he was the patron saint of Florence, where the artist first trained, and he was a favored subject for Mochi.

87 The Art Institute is for-
tunate to own many works
in various media by the great
Dutch master Rembrandt van
Rijn (see no. 119). Old Man
with a Gold Chain depicts
one of Rembrandt's favorite
models from his early years
as an artist. The unidentified
man—his proud, weathered
face dramatically illumi-

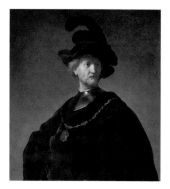

nated—wears a costume that conveys an air of valor
and romance. Through images such as this, the young
and ambitious Rembrandt displayed his technical skills
and revealed the concern for human character that
would absorb him for the rest of his career.

88 Peter Paul Rubens was a prodigiously productive art-
ist. In addition to painting grand altarpieces and design-
ing tapestries and other decorations for many European
rulers, he frequently treated more intimate religious
themes like this Holy Family. In this composition, which
is at once stable and dynamic, the Virgin nurtures the
Christ Child, who interacts with his young cousin, Saint
John the Baptist, while Saint Joseph and the Baptist's
mother, Saint Elizabeth,
look on protectively. The
robust and affectionate
figures express the more
direct religious senti-
ment that was favored
by the Roman Catholic
Church as part of the
Counter-Reformation
movement in the early
17th century.

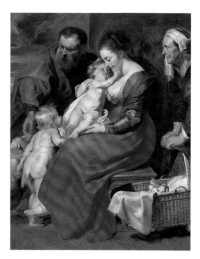

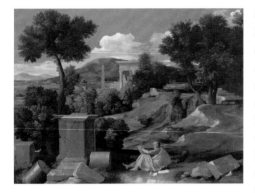

89 Nicolas Poussin addressed noble and serious subjects in his art, but, unlike Rembrandt, he worked with ideal rather than particular forms. The paintings of this French artist who spent most of his life in Rome have become synonymous with the classical strain in 17th-century art. In Landscape with Saint John on Patmos, Poussin carefully constructed an idealized landscape, adjusting natural and man-made forms according to geometric principles to reinforce the measured order of the image. Not a breath of wind disturbs the scene or the concentration with which the Evangelist writes the book of Revelation.

90 Throughout history the finest weapons and armor have been valued as objects of beauty as well as tools of warfare and competition, symbolic of the wealth and power of their owners. Made in the English royal armory established by Henry VIII at Greenwich Palace, this upper portion of an Armor for Field and Tilt mimics the decorative bands and exaggerated pointed waist of court fashion. Created in the workshop headed by the

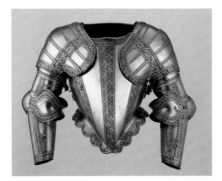

German-born craftsman Jacob Halder, this half suit was made both for courtly use at tournaments and for the battlefield.

91 Giovanni Battista Tiepolo's *Rinaldo Enchanted by Armida* is part of a suite of paintings in the Art Institute illustrating passages from a 16th-century epic about the First Crusade. Rinaldo is diverted by the beautiful sorceress

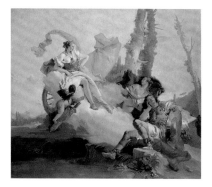

Armida from the crusade to recapture Jerusalem from the Muslims. In this imaginative version of the seduction, Armida appears on a billowing cloud, her shawl and drapery wafting behind her as if a gentle wind has blown the mirage to the sleeping knight. The complex arrangement of figures, draperies, and clouds; the gentle diagonals of the trees and landscape; and the creamy colors further enhance the extraordinary pictorial beauty of this magical world.

92 The greatest portrait sculptor of the 18th century, Jean-Antoine Houdon used all his skill in capturing the poise and elegance of the recently married *Madame de Sérilly*. Precisely cut eye pupils and the lively turn of her head create an impression of intelligence, while her subtly textured hair and skin suggest sensuous beauty. Subsequent to the carving of this bust, Madame de Sérilly's life took a dramatic and painful turn. In 1791 her husband was executed, and she herself barely escaped the guillotine; she died of smallpox eight years later.

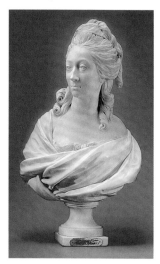

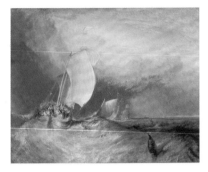

93 Much of the Englishman J. M. W. Turner's career was devoted to increasingly abstract renderings of dramatic atmospheric effects. The low horizon line in Fishing Boats with Hucksters Bargaining for Fish, as well as the subject itself, derives from Turner's exposure during his formative years to 17th-century Dutch sea paintings. But the vulnerability of men and boats under ominous skies and in rough seas and the impotence of man in the face of the overwhelming power of nature are the real subjects of Turner's Romantic image.

94 Édouard Manet is known today as a painter of modern life. Jesus Mocked by Soldiers is one of his rare religious pictures; its subject matter, heroic scale, and dark colors relate it to Old Master paintings. The artist's treatment of this traditional subject, however, is unconventional. The viewer is confronted, like the three tormentors, with a seminaked man whose fate is no

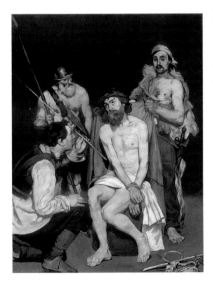

longer his to determine. The raw, powerful impression of the picture is enhanced by Manet's use of stark contrasting colors, flat forms, and thick paint.

95 Included among the Art Institute's great collection of French Impressionism is one of the largest groups of works by Claude Monet outside France. Concentrating on outdoor scenes of

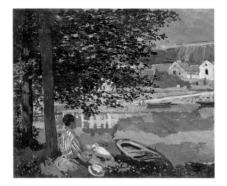

everyday life, he attempted, in works such as On the Bank of the Seine, Bennecourt, to capture conditions of light and atmosphere with bright colors and lively, broken brushstrokes. By boldly applying broad areas of color to his canvas, Monet defined clearly, without exact detail, the dappled patterns of light and shade on the seated figure and boat, the reflections of the calm river, and the strong sunlight on the sleepy village opposite.

96 The unidentified woman in Interrupted Reading is pensive, solitary, and melancholic, the very essence of Romantic sensibility. Using bold and direct brushwork, Jean-Baptiste-Camille Corot explored the female form as a construction of masses that balance and support one another. Gentle light and subtly modulated pigments of browns and grays infuse this formal structure with the softness and intimacy that characterize the landscapes with which the artist achieved fame.

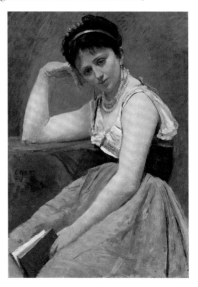

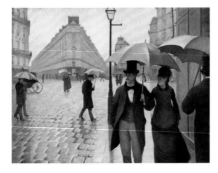

97 Gustave Caillebotte began his career by painting several very large pictures of the newly constructed neighborhoods of northern Paris. One of these, Paris Street; Rainy Day, shows a complex intersection near the Gare Saint-Lazare. A meticulous and highly intellectual artist, Caillebotte based the painting's careful organization on mathematical perspective. Despite its highly organized structure and finished surface, *Paris Street; Rainy Day* expresses the momentary, the casual, and the atmospheric as effectively as the paintings by Degas, Monet, and Renoir included here. This monumental urban view, which measures almost 7 by 10 feet, is considered the artist's masterpiece. The painting dominated the celebrated Impressionist exhibition of 1877, largely organized by Caillebotte himself.

98 Pierre-Auguste Renoir's Acrobats at the Cirque Fernando (Francisca and Angelina Wartenberg) depicts the daughters of a Montmartre circus owner taking a bow after completing their gymnastic act. Renoir surrounded the children with a virtual halo of pinks,

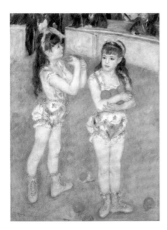

oranges, yellows, and whites, bounded at the top by the railing that separates the ring from the partially seen, darkly clothed, largely male audience. The painting, one of the Art Institute's most popular, was a favorite of its first owner, Mrs. Potter Palmer, who kept it with her at all times, even on her travels abroad.

99 One of the 19th cen-
tury's greatest draftsmen,
Edgar Degas based paint-
ings such as The Millinery
Shop on careful and re-
peated observation, making
many drawings that he then
synthesized in his studio.
This composition, with
its unusual croppings and

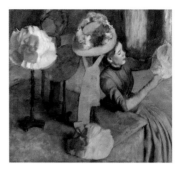

perspective, was calculated to suggest the viewpoint of a
passerby, perhaps looking down at the milliner through
a window. The young Parisian, absorbed in the
fabrication of a new hat, and the brightly colored,
finished bonnets on display next to her are a metaphor
for the effort and skill that underlie all of Degas's art.

100 Georges Seurat's A Sunday on La Grande
Jatte—1884 can be considered the greatest work of his
career. Seurat shared with the Impressionists an inter-
est in the effects of light, but his approach to painting
and composition was far more intellectual than theirs.
By applying dabs of unmixed pigments to the canvas so
that they combine optically in the viewer's mind, Seurat
believed he could achieve great luminosity and vibrance.
This painting took Seurat more than two years to com-
plete and was the result of many preliminary studies.

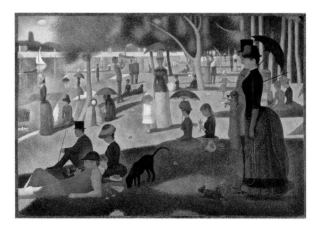

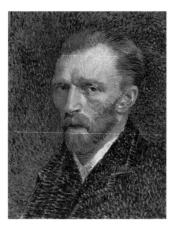

101 Vincent van Gogh painted 24 self-portraits during a two-year stay in Paris (1886–88). In this Self-Portrait, the Dutch artist employed Seurat's dot technique. But what for Seurat was a method based on science became in Van Gogh's hands an intense emotional language. Here the red and green dabs are disturbing and totally in keeping with the nervous tension evident in Van Gogh's gaze. Such self-portraits reveal the profound insecurity and frustration of this talented artist.

102 Like Van Gogh and Gauguin, Henri de Toulouse-Lautrec has become a legend, and his biography is as intriguing as his art. He chose to immerse himself in an aspect of modern life far removed from the sun-dappled scenes of the Impressionists—the spirited nightlife of Montmartre. In At the Moulin Rouge, he focused on a group of friends, clientele, and employees of Paris's most famous dancehall (the artist included himself in the background). The composition—with its oblique perspective, acid palette, bizarre lighting, and masklike faces—is a haunting and unforgettable image

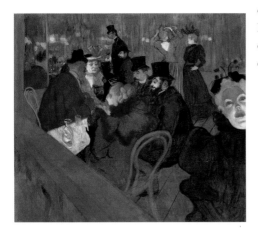

of the dissolute Bohemian life of turn-of-the-century Paris.

103 Paul Gauguin turned away from the Impressionist desire to evoke contemporary life. By removing himself to such remote places as Martinique, Brittany, and, finally, Tahiti, he rejected the modern world and what he considered to be its tired and decadent aesthetic traditions. As its title indicates, The Ancestors of Tehamana is not just a portrait of the artist's Tahitian mistress, but also a study of the mythic elements of non-Western culture. Posed somewhat stiffly, the beautiful young woman seems to listen intently to the messages of the ancestor spirits represented symbolically in the relief behind her.

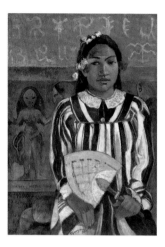

104 Paul Cézanne was the greatest still-life painter of the 19th century, and his contributions to that genre played a principal role in the birth of Cubism. The French painter was drawn to still life not to suggest the touch or taste of the objects depicted but rather to analyze the solidity and essential geometry inherent in each form. Far from being static, such compositions as The Basket of Apples, with its shifting planes (the tabletop and complex folds of the drapery) and brushwork, possess a sense of potential movement. Here Cézanne achieved an image that is at once balanced and dynamic, two- and three-dimensional.

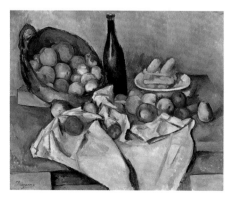

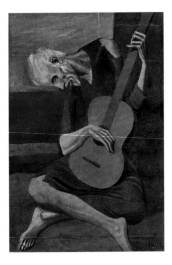

105 Pablo Picasso produced *The Old Guitarist*, one of his most haunting images, while working in Barcelona. In the paintings of his Blue Period (1901–04), of which this is a prime example, Picasso restricted himself to a mono-chromatic palette, flattened forms, and emotional, psycho-logical themes of human misery and alienation related to the work of such artists as Edvard Munch and Van Gogh. With the simplest means, Picasso presented *The Old Guitarist* as a timeless expression of human suffering. He knew what it was like to be poor, having been nearly penniless during all of 1902.

106 During the summer and fall of 1915, Kazimir Malevich produced a series of completely abstract works that he declared constituted an entirely new system of art. Suprematism, as he called this style, eradicated all references to the natural world and focused instead on the

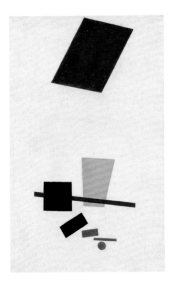

inherent relationships between colored geometric shapes against a subtly textured white background. *Painterly Realism of a Football Player—Color Masses in the 4th Dimension* belongs to this first group of Suprematist works. The second part of its title refers to the mathematical theory of fourth-dimensional space, a concept appropriated by early-20th-century artists to justify their representation of truths beyond immediate sensory perception.

107 Henri Matisse considered Bathers by a River to be one of the five most pivotal works of his career. Originally the composition was a decorative and pastel image

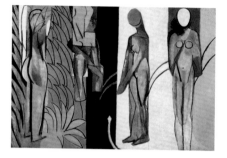

of Arcadia, but over the course of several years, and under the influence of Cubism and the circumstances of World War I, Matisse radically revised his monumental canvas. The result, with its restricted palette and severely abstracted figures, is far removed from the graceful lyricism of the original composition and may, in part, reflect the artist's reaction to the terrible, war-torn period during which he completed it.

108 In his seminal publication *Concerning the Spiritual in Art* (1912), Vasily Kandinsky advocated an art that could move beyond imitation of the physical world to inspire "vibrations in the soul." Pioneering abstraction as the richest, most musical form of artistic expression, Kandinsky produced a revolutionary group of increasingly abstract works, with titles such as *Fugue* and *Improvisation*, hoping to bring painting closer to music making. Although it is an abstract assortment of brilliant colors, shapes, and lines, Improvisation No. 30 (Cannons) still contains identifiable, narrative elements: leaning buildings, a crowd of people, and a wheeled, smoking cannon.

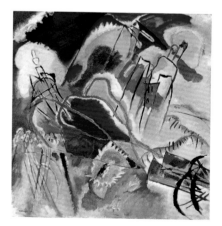

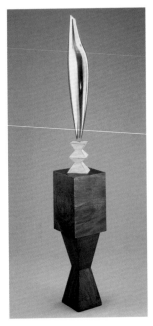

109 Trained in both folk and academic traditions, Constantin Brâncuși began to seek his own path for sculpture around 1907. Breaking with currents of the time, he adopted direct carving, combined different materials for single works, and simplified form in his search for a subject's essential character. More than any other theme, Brâncuși's series of birds, including Golden Bird, summarizes his quest for essential form. Numbering almost 30, the sculptures demonstrate how he continued to distill his primary concept through subtle changes of proportion, material, and surface.

110 Although Piet Mondrian's abstractions seem far removed from nature, his basic vision was rooted in landscape, especially the flat geography of his native Holland. Beginning with his earliest naturalistic landscapes, over time he reduced natural forms to their simplest linear and colored equivalents to suggest unity and order. Finally, he eliminated representational imagery altogether, developing a pure visual language

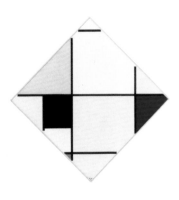

of verticals, horizontals, and primary colors that he believed expressed universal forces. For the 1921 Lozenge Composition with Yellow, Black, Blue, Red, and Gray, Mondrian rotated a square canvas to produce a dynamic but balanced relationship between the rectilinear composition and the diagonal lines of the work's edges.

111 Soon after the Catalan
artist Joan Miró moved to Paris
from his native Barcelona in
1920, he met a group of avant-
garde painters and writers who
advocated merging dreams
and the unconscious with the
everyday rational world in
order to express an absolute
reality, or surreality. To release
images of this higher realm, the
Surrealists embraced automa-

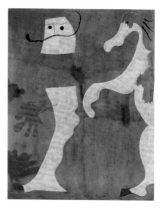

tism, a spontaneous working method much like free
association. Between 1925 and 1927, Miró's experiments
in automatism unleashed a revolutionary series of works
called the *Dream* paintings, which comprise kinetic,
calligraphic forms much like those in The Policeman.

112 Impressed by René Magritte's works at the 1936
International Surrealist Exhibition, the collector
Edward James invited the artist to paint canvases for the
ballroom of his London home. In response, Magritte
made Time Transfixed, his now-famous image of a
tiny locomotive emerging incongruously from the vent
customarily used for a fireplace stovepipe. Magritte
thought carefully about the
titles for his works but later
expressed dissatisfaction with
the English translation of the
French title for this painting,
La Durée poignardée, which
means literally "ongoing
time stabbed by a dagger."
Magritte hoped that James
would install it at the bottom
of his staircase so that the
train would "stab" guests on
their way to the ballroom.

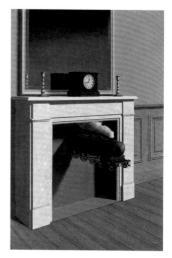

PHOTOGRAPHY

113 William Henry Fox Talbot produced Two Plant Specimens by placing botanical samples on sensitized paper and exposing them to light. He made this groundbreaking discovery in 1833 on a trip to Italy. Frustrated by his inability to accurately draw his surroundings, Talbot wondered whether the fleeting images of external objects that appeared within a camera lucida—an optical prism that creates a superimposed image on an artist's drawing surface—could be made permanent. What resulted, two years later, were the first photographic paper negatives. Unveiled in 1839 as photogenic drawing, Talbot's paper-negative process, called calotype, was patented two years later.

114 The large-format camera was used in the 1860s by Carleton Watkins, one of the great 19th-century photographers of the American West, whose images provided some of the first glimpses of this expansive and unfamiliar territory. In Mendocino River, Watkins conveyed a sense of deep space by capturing the receding planes of mist-laden hills. The clearly discernible details—both near and far—communicate a feeling of clarity and serenity. Watkins's views of Yosemite Valley encouraged

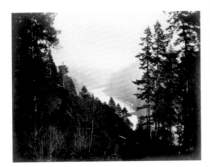

President Abraham Lincoln and the United States Congress to pass legislation protecting this wilderness area.

115 The photographer
Alfred Stieglitz helped bring
to the United States examples
of the revolutionary devel-
opments in modern art in
Europe. He also provided
support for progressive artists
and photographers living and
working in the United States.
His New York gallery 291
exhibited work by such artists
as Picasso, Matisse, John
Marin, Marsden Hartley,

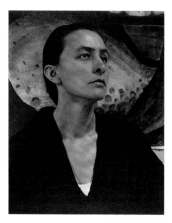

and O'Keeffe, who would become Stieglitz's wife. He
photographed her hundreds of times over the years,
varying the poses and focusing on different parts of her
body in a totally modern approach to the portrait. In
Georgia O'Keeffe, she seems as confident, monumental,
and enigmatically beautiful as her art, which is displayed
behind her.

116 A painter, architect, and designer, as well as a
photographer, El Lissitzky believed that avant-garde art
could transform daily life. He especially enjoyed experi-
menting with the layering possibilities, translucency, and
opacity of photograms, a technique in which images are
made without a camera by placing objects directly on
photographic paper and exposing them to light. Untitled
features a portrait of Lissitzky, with his characteristic
checkered hat and pipe, and his friend Vilmos Huszár, a
De Stijl painter and
designer whose use
of layered rectangles
of color may have
influenced the
composition.

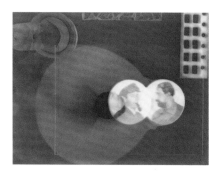

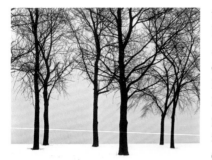

117 Influenced by both the classicism of Ansel Adams and the experimentalism of László Moholy-Nagy, Harry Callahan's photographs fuse formal precision and exploration with personal subjectivity. His high-contrast images of natural subjects are spare, elegant distillations of form and line. One of his best-known pictures, Chicago depicts snow-covered trees along the city's lakefront. Although Callahan captured all of the detail available in the bark and snow in his negative, he purposefully printed this image in high contrast to emphasize the black-and-white forms of the trees against the stark backdrop.

118 A hybrid of photography, film, and installation art, Nan Goldin's The Ballad of Sexual Dependency is a slideshow compiled from thousands of the artist's photographs, accompanied by a specified soundtrack. Goldin's pictures, like images of family vacations or holidays, embrace photography's potential for immediacy, emotion, and anecdote. Unlike snapshots, however, Goldin's photographs capture friends and family in moments of intimacy—lovemaking, violence, addiction, hospitalization—and depict the roller coaster of human emotions that accompany them. In this way, *The Ballad* offers a more exposed, and potentially more honest, version of the traditional domestic slideshow.

PRINTS AND DRAWINGS

119 Rembrandt van Rijn's Self-Portrait at a Window reflects a traditional portrait type used since the 15th century. The artist is caught in the middle of his most intimate and natural activity—creating an etching. In this particularly fine impression of the finished print, Rembrandt used etching to lay in the subject with a dense network of lines, but he

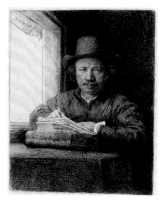

relied on drypoint to define the forms and tiny flecks to suggest the face. His gaze rivets the viewer with a soul-searching energy that seems capable of fueling his late, great painted investigations.

120 In Claude Lorrain's landscapes of the Roman countryside, or Campagna, order and tranquility prevail; men perform no labor but rather exist peacefully in beautiful pastoral settings bathed in warm light. Depicted here is the region around the Sasso, a large rock ten miles south of Civitavecchia, Rome's modern seaport. Evidently made at the site of the rock itself, Panorama from the Sasso is remarkable for its subtle ink washes, which evocatively suggest the landscape and sea. The drawing's horizontal format enhances the idyllic landscape's panoramic sweep.

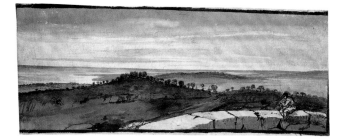

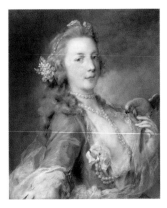

121 Drawings, whether made as studies for other compositions or intended as works of art in themselves, can display a degree of intimacy and freshness that is less often achieved in paintings. One of the few renowned women artists of the early 18th century, the Venetian Rosalba Carriera popularized the pastel portrait. In A Young Lady with a Parrot, silks, ribbons, pearls, lace, flowers, hair, and flesh are defined with lightness and dexterity. The vivacious portrait of a young woman, with her porcelain-like face, cascade of golden curls, and full bosom (revealed by a parrot), exemplifies the flattering portraiture and technical mastery that brought Carriera international fame.

122 Francisco de Goya seems never to have compromised his intense feelings for humanity or his acute vision of man's vanities and vices. Dating from about 1816/20 and showing a girl dancing with abandon, Be Careful with That Step! is part of a series illustrating the follies of the young and old. With an astonishing economy of means—a few simple strokes of his fine-pointed brush—Goya succeeded not only in describing the materials of the girl's dress but also in capturing her quick, lively movements.

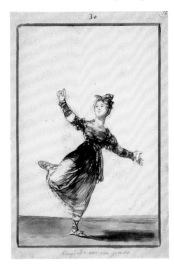

123 Winslow Homer painted his final tropical watercolors in Homosassa, Florida. In Life-Size Black Bass, the artist placed the underside of the huge, brightly colored fish at the

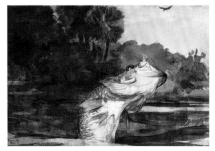

center of the composition, close to the viewer, bringing to life the drama, immediacy, and suspense of the fisherman's experience. With his trademark ambiguity, Homer showed the bass suspended between life and death. The sudden jump of the fish slices through the dark, quiet glade with a momentary flash of life and color.

124 Arshile Gorky, an Armenian immigrant to the United States, developed an abstract painting style influenced by Surrealism, but like many 20th-century artists, he first revealed his skills in representational work. The Artist's Mother is a large charcoal drawing inspired by a photograph of Gorky as a young boy with his mother. Drawing with a careful, classic simplicity, he transformed the woman's dark beauty into the perfect features of an Eastern Orthodox icon.

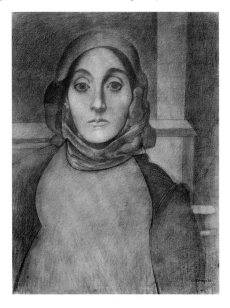

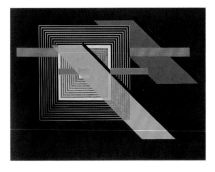

125 Deeply influenced by Communist utopian politics, El Lissitzky created a series of works entitled *Proun*, an acronym that means "for the affirmation of the new art." His pursuit of this new form was meant to do for art what Communism was expected to do for society. This Proun collage displays the artist's increasing interest in Constructivism. Pasted against a black background, sharp-edged painted and transparent collage elements suggest movement and an abstract architectural space. This was precisely the effect Lissitzky hoped to achieve as he questioned and expanded the social aims of art as a spatial and political experience.

126 From around 1961 until 1968, Roy Lichtenstein created a group of highly finished drawings that demonstrate his subversive use of commercial illustration techniques. In Alka Seltzer, he exploited everyday practices of visual representation and magnified them, indicating the gas bubbles rising over the glass by meticulously scraping away extra spaces from a field of imitation, hand-stenciled Benday dots. To signify the

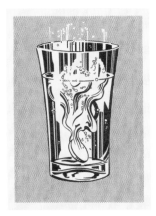

reflective surface of the glass, he drew flat black graphite shapes—a parody, like the dots, of the reductive, linecut effect of pulp advertising. The artist's use of mechanical reproduction conventions served to unify his composition and produce movement and volume on a two-dimensional surface.

TEXTILES

127 Among the earliest items in the museum's collection of textiles is Portion of a Hanging with Warrior, which was created by Christian Egyptians, or Copts, in the 5th or 6th century. Flanked by columns and surrounded by an arch, the boldly outlined figure is striking in its frontality, solemn expression, and animated side glance—all of which relate the hanging to early Christian icons.

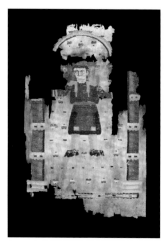

128 The need to wear and use cloth made from plant and animal fibers has proved fertile ground for creative imagination, and various methods have evolved to produce or embellish fabrics. The Spanish Retable and Altar Frontal is a virtual encyclopedia of needlework techniques. This medieval masterpiece was created for the bishop of Osma, Spain, around 1468. The three scenes above—the Madonna and Child, the Nativity, and the Adoration of the Magi—were embroidered to suggest painting. Below the altar appear six apostles and the Resurrection. The relief effect of the figures and colonnade, achieved through padding and stuffing, imitates a sculpted Gothic altar.

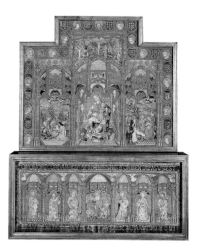

129 This Tunic is composed of a plain-weave cotton cloth completely concealed by thousands of brightly colored feathers. These exotic plumes were taken from a variety of birds found in the tropical forests of South America. There feathers were a rare and valuable commodity, only available to the most elite members of pre-Hispanic society. Thus, the feather tunic would have been a sumptuous emblem of power, wealth, and prestige.

130 This tapestry originally formed part of a suite called *The Story of the Emperor of China*, which portrayed scenes from the lives of the Qing dynasty Shunzhi emperor (r. 1644–61) and his son, the Kangxi emperor (r. 1661–1722). This highly influential series was made by the Beauvais Manufactory in response to the French court's growing interest in the Far East. The Emperor Sailing shows the elder emperor seated in a ceremonial dragon boat as it pulls away from a quay. Members of the imperial family and their attendants watch the launch from an arcaded trellis, in close proximity to a crane and a tortoise that together symbolize well-wishes for the monarch.

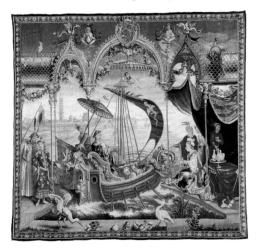

131 Chicago architect George W. Maher was one of many Americans who embraced the English Arts and Crafts movement, incorporating into his residential designs an emphasis on simplicity, natural forms, and respect for materials. This silk and cotton Portière hung over a doorway in Maher's James A. Patten House in Evanston, Illinois, built in 1901. The highly stylized and linear thistle motif, created for this panel and other elements of the Patten House by Maher and designer Louis J. Millet, helped achieve the decorative rhythm and unity that Maher believed was essential to the successful design of any residence.

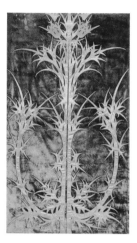

132 This informal Hitoe (an unlined summer kimono) is patterned with water irises, a traditional Japanese motif. The use of bold colors, stylized natural forms, and curvilinear renderings demonstrates the possible influence of the popular European movement known as Art Nouveau. The layered textures from both the gauze weave and the resulting undulation of the shibori technique contrast with the flat stenciling of the irises on the surface, giving the appearance not of the actual flowers, but of their reflection in rippling water.

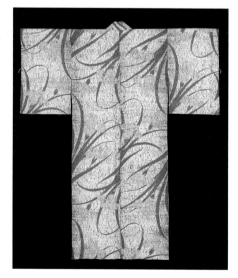

List of Illustrations

h. 170.2 cm. William M. Willner Fund, 1910.238. **31.** *Amphora (Storage Jar)*, 530/520 B.C. Etruscan; attributed to the Ivy Leaf Group. Terracotta, decorated in the black-figure technique; 38.7 x 27.9 cm. Katherine K. Adler Memorial Fund, 2009.75. **32.** *Foot of a Cista (Lidded Chest)*, early 5th century B.C. Etruscan. Bronze; 15.6 x 10.4 x 5.4 cm. Katherine K. Adler Memorial Fund, 1999.559. **33.** *Stamnos (Mixing Jar)*, c. 450 B.C. Greek, Athens; attributed to the Chicago Painter. Terracotta, decorated in the red-figure technique; 37 x 30.9 cm. Gift of Philip D. Armour and Charles L. Hutchinson, 1889.22a–b. **34.** *Fragment of a Funerary Monument*, 4th century B.C. Greek, Athens, Halai Aixonides; attributed to the Demagora Master. Marble, 55.3 x 43.7 x 17.2 cm. Katherine K. Adler Memorial, Mr. and Mrs. Walter Alexander Classical Endowment, Costa A. Pandaleon Greek Art Memorial, and David P. Earle III funds, 2009.76. **35.** *Attachment Fashioned in the Shape of the Upper Body of a Silenos*, 1st century B.C./1st century A.D. Roman. Bronze, silver, and copper; 18.7 x 16.2 x 8.9 cm. Katherine K. Adler Memorial Fund, 1997.554.2. **36.** *Portrait Bust of a Woman*, A.D. 140/50. Roman. Marble; h. 62 cm. Restricted gifts of the Antiquarian Society in honor of Ian Wardropper, Classical Art Society, Mr. and Mrs. Isak V. Gerson, James and Bonnie Pritchard, and Mrs. Hugo Sonnenschein; Mr. and Mrs. Kenneth Bro Fund; Katherine K. Adler, Mr. and Mrs. Walter Alexander in honor of Ian Wardropper, David Earle III, William A. and Renda H. Lederer Family, Chester D. Tripp, and Jane B. Tripp endowments, 2002.11. **37.** *Solidus (Coin) of Emperor Heraclius*, A.D. 638–41. Byzantine, minted in Constantinople. Gold; 4.49 g. Gift of Mrs. Emily Crane Chadbourne, 1940.14. **38.** *Mosaic Fragment with a Man Leading a Giraffe*, 5th century. Byzantine, northern Syria or Lebanon. Stone in mortar; 170.8 x 167 cm. Gift of Mrs. Robert B. Mayer, 1993.345.

Architecture and Design 39. Dankmar Adler and Louis H. Sullivan. *Chicago Stock Exchange Trading Room*, 1893–94; demolished 1972; reconstructed 1976–77. Gift of the Walter E. Heller Foundation through its president, Mrs. Edwin J. DeCosta. **40.** Frank Lloyd Wright. *Avery Coonley Playhouse: Triptych Window*, 1912. Clear and colored leaded glass in oak frames; center panel: 89.5 x 109.2 cm. Restricted gift of Dr. and Mrs. Edwin J. DeCosta and the Walter E. Heller Foundation, 1986.88. **41.** Ludwig Mies van der Rohe. *Court House Study: Interior View Showing Steel Columns*, 1931/38. Ink on paper, mounted on archival board; 21.4 x 29.9 cm. Gift of A. James Speyer, 1981.937. **42.** Diller + Scofidio. *Automarionette*, c. 1987. Ink on Mylar; 60.9 x 30.4 cm. Gift of Celia and David Hilliard in honor of Stanley Tigerman and Eva Maddox, 2008.67. **43.** Tokujin Yoshioka. *Honey-Pop Armchair*, 2001. Honeycomb paper construction consisting of white wove, highly calendered paper; 79.4 x 81.3 x 81.3 cm (unfolded). Restricted gift of the Architecture and Design Society, 2007.111. **44.** Jeanne Gang, Studio Gang Architects. *Aqua Tower, Chicago, Illinois, Presentation Model*, 2005. Acrylic; 106.7 x 40.6 x 40.6 cm. Restricted gift of the Architecture and

Design Society, 2011.115. **45.** Hulger and Samuel Wilkinson Design. *Plumen*, 2010. Glass, ABS plastic, and metal; 7.6 x 6.1 x 3.3 cm. Gift of Hulger, 2011.784. **46.** Aaron Koblin. *Flight Patterns*, 2011. Animation. Restricted gift of the Architecture and Design Society, 2011.275.

Asian Art 47. *Wine Vessel (Fanglei)*, Shang dynasty (c. 1600–c. 1050 B.C.), 12th/11th century B.C. China. Bronze; 45 x 24.8 cm. Lucy Maud Buckingham Collection, 1938.17. **48.** *Sheath with Bird and Feline or Dragon*, Warring States period/Western Han dynasty, 3rd/2nd century B.C. China. Jade (nephrite); 10.6 x 5.7 x .5 cm. Through prior gifts of Mrs. Chauncey B. Borland, Lucy Maud Buckingham Collection, Emily Crane Chadbourne, Mary Hooker Dole, Edith B. Farnsworth, Mary A. B. MacKenzie, Mr. and Mrs. Chauncey B. McCormick, Fowler McCormick, Mrs. Gordon Palmer, Grace Brown Palmer, Chester D. Tripp, Russell Tyson, H. R. Warner, Joseph Winterbotham, and Mr. and Mrs. Edward Ziff, 1987.141. **49.** Li Huayi. *Landscape*, 2002. Ink and color on paper; 182 x 98.3 cm. Comer Foundation Fund, 2004.450. **50.** *Bishamon*, Heian period (794–1185), 11th century. Japan. Wood with traces of polychromy; h. approx. 135 cm. Robert Allerton Endowment, 1968.145. **51.** *Legends of the Yūzū Nembutsu*, mid-14th century. Japan. Handscroll; ink, color, and gold on paper; 30.5 x 1176.9 cm. Kate S. Buckingham Endowment, 1956.1256. **52.** Kaigetsudo Anchi. *A Beauty*, c. 1714. Hand-colored woodblock print; ō-ōban, tan-e; 55.2 x 28.8 cm. Clarence Buckingham Collection, 1925.1741. **53.** *Ewer*, Goryeo dynasty, 12th century. Korea. Stoneware with celadon glaze and incised decoration; 21.4 x 8.3 cm. Bequest of Russell Tyson, 1964.1213. **54.** *Karttikeya, God of War, Seated on a Peacock*, Ganga period, c. 12th century. India, Andhra Pradesh, Madanapalle. Granite; 150.5 x 121 x 39 cm. Restricted gift of Mr. and Mrs. Sylvain S. Wyler, 1962.203. **55.** *A Monumental Portrait of a Monkey*, 1705/10. India, Rajasthan, Mewar, Udaipur; attributed to the Stipple Master. Opaque watercolor and gold on paper; 48.5 x 58.7 cm. Lacy Armour Fund and James and Marilynn Alsdorf Acquisition Fund, 2011.248. **56.** *Mandala of Vasudhara, Goddess of Wealth*, 19th century. Tibet or Nepal. Silver and gilt copper; 8.9 x 33 cm. Russell Tyson Fund, 1979.616. **57.** *Bowl (Tas) with Horsemen and Solar Motif*, 14th century. Southern Iran, probably Fars. Brass inlaid with silver; 10.3 x 20.3 cm. Bequest of Russell Tyson, 1964.563. **58.** *Two Tiles in the Saz Style*, c. 1560. Turkey, Ottoman period, Iznik. Fritware with underglaze painting in blue, turquoise, green, black, and red slip; 27.9 x 22.2 cm. Mary Jane Gunsaulus Collection, 1917.219a-b.

Contemporary Art 59. Willem de Kooning. *Excavation*, 1950. Oil on canvas; 205.7 x 254.6 cm. Mr. and Mrs. Frank G. Logan Purchase Prize Fund; restricted gifts of Edgar J. Kaufmann, Jr., and Mr. and Mrs. Noah Goldowsky, Jr., 1952.1. **60.** Robert Rauschenberg. *Short Circuit (Combine Painting)*, 1955. Oil, fabric, and paper on wood supports and cabinet with two hinged doors containing a painting by Susan Weil and a reproduction of a Jasper Johns *Flag* painting by

Sturtevant; 103.5 x 95.2 x 10.8 cm. Through prior purchase of the Grant J. Pick Purchase Fund; through prior bequest of Sigmund E. Edelstone; Frederick W. Renshaw Acquisition Fund; Estate of Walter Aitken, Alyce and Edwin DeCosta, Walter E. Heller Foundation, and Ada Turnbull Hertle funds; Wirt D. Walker Trust; Marian and Samuel Klasstorner, Mrs. Clive Runnells, Alfred and May Tiefenbronner Memorial, Boles C. and Hyacinth G. Drechney, Charles H. and Mary F. Worcester Collection, Mary and Leigh Block Endowment, Gladys N. Anderson, Benjamin Argile Memorial, Director's, and Joyce Van Pilsum funds, 2011.247. **61.** Cy Twombly. *The First Part of the Return from Parnassus*, 1961. Oil paint, lead pencil, wax crayon, and colored pencil on canvas; 240.7 x 300.7 cm. Through prior gift of Mary and Leigh Block, Marian and Samuel Klasstorner Fund, Major Acquisitions Endowment Income Fund, Wirt D. Walker Trust, Estate of Walter Aitken, Director's Fund, Helen A. Regenstein Endowment, and Laura T. Magnuson Acquisition Fund, 2007.63. **62.** Gerhard Richter. *Woman Descending the Staircase*, 1965. Oil on canvas; 198 x 128 cm. Roy J. and Frances R. Friedman Endowment; gift of Lannan Foundation, 1997.176. **63.** Eva Hesse. *Hang Up*, 1966. Acrylic on cloth over wood, and acrylic on cord over steel tube; 182.9 x 213.4 x 198.1 cm. Through prior gifts of Arthur Keating and Mr. and Mrs. Edward Morris, 1988.130. **64.** Andy Warhol. *Mao*, 1973. Synthetic polymer paint and silkscreen ink on canvas; 448.3 x 346.7 cm. Mr. and Mrs. Frank G. Logan Purchase Prize and Wilson L. Mead funds, 1974.230. **65.** Roy Lichtenstein. *Mirror #3 (Six Panels)*, 1971. Oil and Magna on canvas; 305 x 335 cm. Anstiss and Ronald Krueck Fund for Contemporary Art, facilitated by the Roy Lichtenstein Foundation, 2005.18. **66.** Kerry James Marshall. *Many Mansions*, 1994. Acrylic on paper, mounted on canvas; 289.6 x 342.9 cm. Max V. Kohnstamm Fund, 1995.147. **67.** Jasper Johns. *Near the Lagoon*, 2002–03. Encaustic on canvas and wooden boards with objects; 300 x 198.1–214.6 (variable) x 10 cm. Through prior gift of Muriel Kallis Newman in memory of Albert Hardy Newman, 2004.146. **68.** Charles Ray. *Hinoki*, 2007. Cypress; three elements: 172.7 x 762 x 233.7 cm; 63.5 x 426.7 x 208.3 cm; and approx. 60.5 x 400 x 200 cm. Through prior gifts of Mary and Leigh Block, Mr. and Mrs. Joel Starrels, Mrs. Gilbert W. Chapman, and Mr. and Mrs. Roy J. Friedman, re-stricted gift of Donna and Howard Stone, 2007.771. **European Decorative Arts 69.** Hans Ludwig Kienle. *Cup in the Form of a Rearing Horse and Rider*, 1630. Silver, cast and partly gilt; h. 31.5 cm. Restricted gift of Mr. and Mrs. Stanford D. Marks, Mrs. Eric Oldberg, and Mrs. Edgar J. Uihlein; Albert D. Lasker, Howard V. Shaw Memorial, and European Decorative Arts funds; James W. and Marilynn Alsdorf, Pauline S. Armstrong, Harry and Maribel G. Blum, Michael A. Bradshaw and Kenneth S. Harris, Tillie C. Cohn, Richard T. Crane, Jr., Memorial, Eloise W. Martin, Henry Horner Strauss, Mr. and Mrs. Joseph Varley, and European Decorative Arts endowments; through prior acquisitions of Kate S. Buckingham and the George F. Harding Collection in honor of Eloise W. Martin, 2003.114. **70.** André-Charles

Boulle. *Casket*, early 18th century. Oak carcass veneered with tortoiseshell, gilt copper, pewter, and ebony; gilt-bronze mounts; 44.5 x 73 x 48.3 cm. Michael A. Bradshaw and Kenneth S. Harris, Eloise W. Martin, Richard T. Crane, Jr., Memorial, and European Decorative Arts Purchase funds; through prior acquisitions of Mrs. C. H. Boissevain in memory of Henry C. Dangler, Kate S. Buckingham Endowment, David Dangler, Harold T. Martin, and Katherine Field-Rodman, 2001.54. **71.** Meissen Porcelain Manufactory, modeled by Johann Joachim Kändler. *King Vulture*, 1734. Hard-paste porcelain and polychrome enamel; 58 x 43 cm. Gift of Harry A. Root, Doris and Stanford Marks, Fred and Kay Krehbiel, Maureen and Edward Byron Smith, Jr., Elizabeth Souder Louis, Ira and Barbara Eichner Charitable Foundation, Lori Gray Faversham, and the Women's Board of the Alliance Française; Lacy Armour Fund; the Antiquarian Society; Kate S. Buckingham, Charles H. and Mary F. S. Worcester Collection, and Frederick W. Renshaw Acquisition funds; Robert Allerton Trust; Mary and Leigh Block Endowment and Northeast Auction Sales Proceeds funds; Kay and Frederick Krehbiel Endowment; Centennial Major Acquisitions Income, Ada Turnbull Hertle, Wirt D. Walker, Gladys N. Anderson, Robert Allerton Purchase Income, and Pauline Seipp Armstrong funds; Edward E. Ayer Fund in Memory of Charles L. Hutchinson; Marian and Samuel Klasstorner Fund; Helen A. Regenstein Endowment; Director's Fund; Maurice D. Galleher Endowment; Laura T. Magnuson Acquisition Fund; Samuel A. Marx Purchase Fund for Major Acquisitions; Edward Johnson Fund; Harry and Maribel G. Blum Endowment; Bessie Bennett Fund; Hugh Leander and Mary Trumbull Adams Memorial Endowment; Wentworth Greene Field Memorial and Elizabeth R. Vaughn funds; Capital Campaign General Acquisitions Endowment; European Decorative Arts Purchase, Samuel P. Avery, Mrs. Wendell Fentress Ott, Irving and June Seaman Endowment, Grant J. Pick Purchase, Betty Bell Spooner, and Charles U. Harris Endowed Acquisition funds, 2007.105. **72.** Du Paquier Porcelain Manufactory. *Gaming Set*, 1735/40. Hard-paste porcelain, polychrome enamels, gilt mounts, and diamonds; 16.8 x 14.8 cm. Eloise W. Martin Fund; Richard T. Crane, Jr., and Mrs. J. Ward Thorne endowments; through prior gift of the Antiquarian Society, 1993.349. **73.** Charles Frederick Kandler. *Wine Jug*, 1739/40. Silver; h. 34 cm. Gift of the Antiquarian Society, 2004.718. **74.** David Roentgen. *Secretary Desk*, c. 1775. Walnut with inlaid tinted woods of chinoiserie motifs, bronze ormolu mounts, and intarsia panels; bottom: 106.4 x 137.8 x 61.3 cm; top: 150.5 x 139.1 x 36.8 cm. Gift of Count Pecci-Blunt, 1954.21. **75.** Sèvres Porcelain Manufactory, designed by Charles Percier, decoration designed by Alexandre-Théodore Brongniart. *Londonderry Vase*, 1813. Hard-paste porcelain, polychrome enamel, gilding, and ormolu mounts; h. 137.2 cm. Gift of the Harry and Maribel G. Blum Fund; Harold L. Stuart Endowment, 1987.1. **76.** Designed by Edward William Godwin, made by William Watt, Art Furniture Warehouse. *Sideboard*, c. 1877. Ebonized mahogany with glass

and silver-plated copper alloy; 184.2 x 255.3 x 50.2 cm (with leaves extended). Restricted gift of Robert Allerton, Harry and Maribel G. Blum, Mary and Leigh Block, Mary Waller Langhorne, Mrs. Siegfried G. Schmidt, Tillie C. Cohn, Richard T. Crane, Jr., Memorial, Eugene A. Davidson, Harriott A. Fox, Florence L. Notter, Kay and Frederick Krehbiel, European Decorative Arts Purchase, and Irving and June Seaman endowments; through prior acquisition of the Reid Martin Estate, 2005.529. **77.** Designed by Josef Hoffmann and Carl Otto Czeschka. *Tall-Case Clock*, c. 1906. Painted maple, ebony, mahogany, gilt brass, glass, silver-plated copper, and clockworks; 179.5 x 46.5 x 30.5 cm. Laura Matthews and Mary Waller Langhorne endowments, 1983.37. **78.** Mrs. James Ward Thorne. *English Drawing Room of the Georgian Period*, c. 1800, 1937/40. Miniature room, mixed media; 28.6 x 48.3 x 41.9 cm. Gift of Mrs. James Ward Thorne, 1941.1197.

Medieval to Modern European Painting and Sculpture **79.** *Reliquary Casket of Saints Adrian and Natalia*, 12th century. Northern Spain. Repoussé silver on oak core; 15.9 x 25.4 x 14.5 cm. Kate S. Buckingham Endowment, 1943.65. **80.** Giovanni di Paolo. *Ecce Agnus Dei*, 1455/60. Tempera on panel; 68.5 x 39.5 cm. Mr. and Mrs. Martin A. Ryerson Collection, 1933.1011. **81.** Jean Hey (Master of Moulins). *The Annunciation*, 1490/95. Oil on panel; 72 x 50.2 cm. Mr. and Mrs. Martin A. Ryerson Collection, 1933.1062. **82.** El Greco (Domenikos Theotokopoulos). *The Assumption of the Virgin*, 1577–79. Oil on canvas; 403.2 x 211.8 cm. Gift of Nancy Atwood Sprague in memory of Albert Arnold Sprague, 1906.99. **83.** Alessandro Vittoria. *The Annunciation*, c. 1583. Bronze; 97.8 x 61.6 cm. Edward E. Ayer Endowment in memory of Charles L. Hutchinson, 1942.249. **84.** Franz Dotte. *Ewer and Basin*, c. 1596. Silver gilt; h. 36.8 cm. Buckingham Fund, 1947.477a–b. **85.** Bartolomeo Manfredi. *Cupid Chastised*, 1613. Oil on canvas; 175.3 x 130.6 cm. Charles H. and Mary F. S. Worcester Collection, 1947.58. **86.** Francesco Mochi. *Bust of a Youth (Saint John the Baptist?)*, c. 1630. Marble; h. 40.5 cm (without base). From the collection of the estate of Federico Gentili di Giuseppe; restricted gift of Mrs. Harold T. Martin through the Antiquarian Society; Major Acquisitions Centennial Endowment; through prior gift of Arthur Rubloff; European Decorative Arts Purchase Fund, 1989.1. **87.** Rembrandt Harmensz. van Rijn. *Old Man with a Gold Chain*, c. 1631. Oil on panel; 83.1 x 75.7 cm. Mr. and Mrs. W. W. Kimball Collection, 1922.4467. **88.** Peter Paul Rubens. *The Holy Family with Saints Elizabeth and John the Baptist*, c. 1615. Oil on panel; 114.5 x 91.5 cm. Major Acquisitions Fund, 1967.229. **89.** Nicolas Poussin. *Landscape with Saint John on Patmos*, 1640. Oil on canvas; 100.3 x 136.4 cm. A. A. Munger Collection, 1930.500. **90.** Jacob Halder and Workshop. *Portions of an Armor for Field and Tilt*, c. 1590. Steel, etched and gilded; iron; brass; and leather; h. 61 cm. George F. Harding Collection, 1982.2241a–h. **91.** Giovanni Battista Tiepolo. *Rinaldo Enchanted by Armida*, 1742/45. Oil on canvas; 187.5 x 216.8 cm. Bequest

of James Deering, 1925.700. **92.** Jean-Antoine Houdon. *Bust of Anne-Marie-Louise Thomas de Domangeville de Sérilly, comtesse de Pange*, 1780. Marble; h. 89.9 cm. Through prior acquisitions of the George F. Harding Collection; Lacy Armour, Harry and Maribel G. Blum Foundation, Richard T. Crane, Jr., and European Decorative Arts Purchase funds; Eloise W. Martin and European Decorative Arts Purchase funds; restricted gift of the Woman's Board in honor of Gloria Gottlieb and Mrs. Eric Oldberg; through prior acquisitions of Robert Allerton, Mary and Leigh Block, Mr. and Mrs. Robert Andrew Brown, Miss Janet Falk, J. S. Landon Fund, Brooks and Hope B. McCormick, Mr. and Mrs. Joseph Regenstein, Sr., Mrs. Florene Schoenborn, and the Solomon A. Smith Charitable Trust through the Antiquarian Society, 1996.79. **93.** J. M. W. Turner. *Fishing Boats with Hucksters Bargaining for Fish*, 1837/38. Oil on canvas; 174.5 x 224.9 cm. Mr. and Mrs. W. W. Kimball Collection, 1922.4472. **94.** Édouard Manet. *Jesus Mocked by Soldiers*, 1865. Oil on canvas; 190.8 x 148.3 cm. Gift of James Deering, 1925.703. **95.** Claude Monet. *On the Bank of the Seine, Bennecourt*, 1868. Oil on canvas; 81.5 x 100.7 cm. Potter Palmer Collection, 1922.427. **96.** Jean-Baptiste-Camille Corot. *Interrupted Reading*, c. 1870. Oil on canvas, mounted on board; 92.5 x 65.1 cm. Potter Palmer Collection, 1922.410. **97.** Gustave Caillebotte. *Paris Street; Rainy Day*, 1877. Oil on canvas; 212.2 x 276.2 cm. Charles H. and Mary F. S. Worcester Collection, 1964.336. **98.** Pierre-Auguste Renoir. *Acrobats at the Cirque Fernando (Francisca and Angelina Wartenberg)*, 1879. Oil on canvas; 131.5 x 99.5 cm. Potter Palmer Collection, 1922.440. **99.** Edgar Degas. *The Millinery Shop*, 1879/86. Oil on canvas; 100 x 110.7 cm. Mr. and Mrs. Lewis Larned Coburn Memorial Collection, 1933.428. **100.** Georges Seurat. *A Sunday on La Grande Jatte—1884*, 1884–86. Oil on canvas; 207.5 x 308.1 cm. Helen Birch Bartlett Memorial Collection, 1926.224. **101.** Vincent van Gogh. *Self-Portrait*, 1887. Oil on artist's board, mounted on cradled panel; 41 x 32.5 cm. Joseph Winterbotham Collection, 1954.326. **102.** Henri de Toulouse-Lautrec. *At the Moulin Rouge*, 1892/95. Oil on canvas; 123 x 141 cm. Helen Birch Bartlett Memorial Collection, 1928.610. **103.** Paul Gauguin. *The Ancestors of Tehamana*, or *Tehamana Has Many Parents*, 1893. Oil on canvas; 76.3 x 54.3 cm. Gift of Mr. and Mrs. Charles Deering McCormick, 1980.613. **104.** Paul Cézanne. *The Basket of Apples*, c. 1893. Oil on canvas; 65 x 80 cm. Helen Birch Bartlett Memorial Collection, 1926.252. **105.** Pablo Picasso. *The Old Guitarist*, 1903–04. Oil on panel; 122.9 x 82.6 cm. Helen Birch Bartlett Memorial Collection, 1926.253. **106.** Kazimir Malevich. *Painterly Realism of a Football Player—Color Masses in the 4th Dimension*, 1915. Oil on canvas; 70.2 x 44.1 cm. Through prior gifts of Charles H. and Mary F. S. Worcester Collection; Mrs. Albert D. Lasker in memory of her husband, Albert D. Lasker; and Mr. and Mrs. Lewis Larned Coburn Memorial Collection, 2011.1. **107.** Henri Matisse. *Bathers by a River*, 1909–10, 1913, and 1916–17. Oil on canvas; 259.7 x 389.9 cm. Charles H. and Mary F. S. Worcester Collection, 1953.158.

108. Vasily Kandinsky. *Improvisation No. 30 (Cannons)*, 1913. Oil on canvas; 109.2 x 110.5 cm. Arthur Jerome Eddy Memorial Collection, 1931.511. **109.** Constantin Brâncuşi. *Golden Bird*, 1919/20 (wood base, c. 1922). Bronze, stone, and wood; 217.8 x 29.9 x 29.9 cm. Partial gift of the Arts Club of Chicago; restricted gift of various donors; through prior bequest of Arthur Rubloff; through prior restricted gift of William Hartmann; through prior gifts of Mr. and Mrs. Carter H. Harrison, Mr. and Mrs. Arnold H. Maremont through the Kate Maremont Foundation, Woodruff J. Parker, Mrs. Clive Runnells, Mr. and Mrs. Martin A. Ryerson, and various donors, 1990.88. **110.** Piet Mondrian. *Lozenge Composition with Yellow, Black, Blue, Red, and Gray*, 1921. Oil on canvas; 60 x 60 cm. Gift of Edgar Kaufmann, Jr., 1957.307. **111.** Joan Miró. *The Policeman*, 1925. Oil on canvas; 248 x 194.9 cm. Bequest of Claire Zeisler, 1991.1499. **112.** René Magritte. *Time Transfixed*, 1938. Oil on canvas; 147 x 98.7 cm. Joseph Winterbotham Collection, 1970.426.

Photography 113. William Henry Fox Talbot. *Two Plant Specimens*, 1839. Photogenic drawing, stabilized in potassium bromide; 22.1 x 18 cm. Edward E. Ayer Endowment in memory of Charles L. Hutchinson, 1972.325. **114.** Carleton Watkins. *Mendocino River, from the Rancherie, Mendocino County, California*, 1863/68. Albumen silver print from collodion negative; 40 x 52.5 cm. Gift of the Auxiliary Board, 1981.649. **115.** Alfred Stieglitz. *Georgia O'Keeffe*, 1919. Palladium print, solarized; 25.1 x 20.2 cm. Alfred Stieglitz Collection, 1949.755. **116.** El Lissitzky. *Untitled*, 1923. Gelatin silver photogram; 17.6 x 23.7 cm. Mary L. and Leigh B. Block Collection, 1992.100. **117.** Harry Callahan. *Chicago*, 1950. Gelatin silver print; 19.2 x 24.2 cm. Mary L. and Leigh B. Block Endowment, 1983.65. **118.** Nan Goldin. *The Ballad of Sexual Dependency*, 1979–2001. Multimedia installation; running time: 43 minutes. Through prior bequest of Marguerita S. Ritman; restricted gift of Dorie Sternberg, the Photography Associates, Mary L. and Leigh B. Block Endowment, Robert and Joan Feitler, Anstiss and Ronald Krueck, Karen and Jim Frank, and Martin and Danielle Zimmerman, 2006.158.

Prints and Drawings 119. Rembrandt Harmensz. van Rijn. *Self-Portrait at a Window, Drawing on an Etching Plate*, 1648. Etching, drypoint, and burin, on ivory laid paper; 16 x 13 cm. Amanda S. Johnson and Marion J. Livingston Endowment; Clarence Buckingham Collection, 2004.88. **120.** Claude Lorrain. *Panorama from the Sasso*, 1649/55. Pen and brown ink, with brush and brown wash, heightened with white gouache and traces of white chalk, over black chalk and traces of graphite, on cream laid paper; 16.2 x 40.2 cm. Helen Regenstein Collection, 1980.190. **121.** Rosalba Carriera. *A Young Lady with a Parrot*, c. 1730. Pastel on blue laid paper, mounted on laminated paperboard; 60 x 50 mm. Helen Regenstein Collection, 1985.40. **122.** Francisco José de Goya y Lucientes. *Be Careful with That Step!*, 1816/20. Brush with black ink and gray and black wash on ivory laid paper; 26.4 x 18.2 cm. Helen Regenstein Collection, 1958.542R. **123.** Winslow Homer. *Life-Size Black Bass*, 1904. Transparent watercolor, with touches of opaque watercolor, blotting, and scraping, over graphite, on thick, moderately textured (twill texture on verso) ivory wove paper; left, right, and lower edges trimmed; 35 x 52.6 cm. Bequest of Brooks McCormick, 2007.115. **124.** Arshile Gorky. *The Artist's Mother*, 1926 or 1936. Charcoal on ivory laid paper; 63 x 48.5 cm. Worcester Sketch Fund, 1965.510. **125.** El Lissitzky. *Proun*, 1924–25. Collage of various cut-and-tipped wove papers (prepared with gouache, graphite, and varnish), and brush and pen and black ink, with red watercolor, on cream laminate cardboard; 49.8 x 65 cm. Gift of Dorothy Braude Edinburg to the Harry B. and Bessie K. Braude Memorial Collection, 1998.734. **126.** Roy Lichtenstein. *Alka Seltzer*, 1966. Graphite, with scraping and lithographic crayon pochoir, on cream wove paper; 76.3 x 56.7 cm. Margaret Fisher Endowment, 1993.176.

Textiles 127. *Portion of Hanging with Warrior*, 5th/6th century. Egypt, Coptic. Linen and wool, plain weave with supplementary wefts forming uncut pile and embroidered linen pile formed by variations of back and stem stitches; 136.5 x 88.3 cm. Grace R. Smith Textile Endowment, 1982.1578. **128.** *Retable and Altar Frontal*, c. 1468. Spain, El Burgo de Osma. Linen, plain weave; appliquéd with linen and silk, plain weaves and silk, plain weave with supplementary pile warps forming cut solid velvet; retable: embroidered with silk floss and creped yarns, gilt- and silvered-metal-strip-wrapped silk in brick, bullion, chain, outline, split, stem and a variety of satin stitches; laid work, couching, and padded couching; seed pearls and spangles; altar frontal: embroidered with linen, silk, gilt-metal-strip-wrapped silk in satin and split stitches; laid work, couching, and padded couching; spangles; retable: 165.2 x 200.8 cm; altar frontal: 88.8 x 200.3 cm. Gift of Mrs. Chauncey McCormick and Mrs. Richard Ely Danielson, 1927.1779a–b. **129.** *Feathered Tunic with Felines, Birds, and Fish*, 1470/1532. Chimú or Inca, Peru. Cotton, plain weave; embellished with feathers knotted and attached with cotton yarns in overcast stitches; 85.1 x 86 cm. Kate S. Buckingham Endowment, 1955.1789. **130.** *The Emperor Sailing*, from *The Story of the Emperor of China*, 1716/22. After a design by Guy-Louis Vernansal, produced at the Manufacture Royale de Beauvais. Wool, silk, and silvered- and gilt-metal-wrapped silk, slit and double interlocking tapestry weave with some areas of 2:2 plain interlacings of silvered- and gilt-metal-wrapped-silk wefts; 385.8 x 355 cm. Charles H. and Mary F. S. Worcester Fund, 2007.22. **131.** *Portière*, 1901. Designed by George Washington Maher and Louis J. Millet for the James A. Patterson House in Evanston, Illinois. Cotton and silk, plain weave with pile warps forming cut solid velvet; appliquéd with silk and cotton, satin damask weave; linen and gilt-metal-strip-wrapped linen, satin weave; cotton and wild silk, plain weaves; embroidered with silk, cotton, linen, and gilt-metal-strip-wrapped linen in chain, cross, and overcast chain stitches; 203.7 x 121.9 cm. Restricted gift of the Antiquarian Society, 1971.680. **132.** *Hitoe*, late Meiji/early Taisho period, 1900/16. Japan. Silk, plain weave self-patterned by rows of gauze crossings (*yoko-ro*); resist-dyed (*shibori*) and stenciled (*kata yuzen-zome*); 141.9 x 126.4 cm. Gift of Mary V. and Ralph E. Hays, 1999.594.